Sex and Humor

Selections from The Kinsey Institute

Edited by

Catherine Johnson, Betsy Stirratt, and John Bancroft

BLOOMINGTON & INDIANAPOLIS

Indiana University Press

Sex and Humor: Selections from The Kinsey Institute—an exhibition at the School of
Fine Arts Gallery, Indiana University, Bloomington, February 8 – March 9, 2002.

The Kinsey Institute for Research in Sex, Gender, and Reproduction
Indiana University
Morrison Hall 313
Bloomington, IN 47405
812-855-7686
www.kinseyinstitute.org

This book is a publication of
Indiana University Press
601 North Morton Street
Bloomington, IN 47404-3797 USA

http://iupress.indiana.edu

Telephone orders 800-842-6796
Fax orders 812-855-7931
Orders by e-mail iuporder@indiana.edu

MANUFACTURED IN HONG KONG

Library of Congress Cataloging-in-Publication Data

Sex and humor : selections from The Kinsey Institute / edited by
 Catherine Johnson, Betsy Stirratt, and John Bancroft
 p. cm.
 ISBN 0-253-34044-6 (cloth : alk. paper)
 1. Sex—Exhibitions. 2. Sex—Humor—Exhibitions. I. Johnson,
Catherine, date. II. Stirratt, Betsy. III. Bancroft, John. IV. Kinsey
Institute for Research in Sex, Gender, and Reproduction. V. Indiana
University, Bloomington. Fine Arts Gallery
HQ23 .S465 2002
306.7'074—dc21
 2001003178

1 2 3 4 5 07 06 05 04 03 02

Contents

Foreword

The relationship of sexuality and humor is a recurrent theme in the collections at The Kinsey Institute. When the School of Fine Arts Gallery began to collaborate with the Institute on exhibitions of art, photography, and ephemera, the topic of sex and humor had obvious universal interest. The holdings contain vast numbers of silly greeting cards, naughty objects, cartoons, jokes, and toys. It is clear that much of the collection is humorous in some way, and that these pieces are likely to be some of the most memorable and engaging.

These materials make it evident that people have often had to use humor to speak about sex. Because talking about sex was unacceptable in most social situations, people became very creative in the ways that they communicated their interests. The Kinsey Institute's collection contains cartoons and greeting cards that were published and sold to the public, but also contains jokes, toys, and eight-pagers (erotic comic books) that were traded or sold outside the mainstream. While many of these cards, books, and objects were commercially produced, a number of photographs and ephemera were created by amateurs to share with friends.

The exhibition contains objects from a variety of cultures and time periods. There are some important examples of amusing art dating from the mid–eighteenth century and earlier, illustrating that jokes, cartoons, puns, and other forms of humor have always been an important way for people to communicate about sex. Humor about sex continues to be part of our everyday lives, and it remains one of the few acceptable ways that sex can be discussed in polite company.

We are fortunate that The Kinsey Institute chooses to share these important artifacts through this exhibition. I am grateful that the Institute continues to exhibit these important collections at the School of Fine Arts Gallery, and I would like to thank the staff of the Institute for their enthusiasm for this project. John Bancroft, director of The Kinsey Institute, and I have discussed ideas for this show several times over the years, and I am glad to see it successfully come to fruition. I would also like to thank Catherine Johnson for her curatorial work on this project, most notably her valuable insight into the nuances of the selected works.

This project examines an often-ignored portion of our sexual history. Humor and sex are both integral parts of everyday life and important for overall health and happiness. I hope this exhibition and catalog prove to be enjoyable and funny as well.

Betsy Stirratt
Director, School of Fine Arts Gallery

Acknowledgments

We would like to express our sincere gratitude to all the people who have helped us with this book, beginning with the three individuals who generously contributed essays—Mikita Brottman, Frank Hoffmann, and Leonore Tiefer. This book will have much greater value as a text on the subject of sex and humor due to their thoughtful contributions. Our thanks also to the staff at The Kinsey Institute, who have told us what they thought was funny (or not) and have offered assistance in many other ways. Special thanks to Shawn Wilson and Liana Zhou of The Kinsey Institute Library, to Sandy Ham, and to the students who work with the art collection as curatorial assistants: Kerry Laws, Mary Corinne Lowenstein, and Chandra Ramey.

We would also like to thank the individuals who have given us advice, information, and other help with this project: Sarah Burns, Lori Dekydtspotter, Susan Johnson-Roehr, Sumie Jones, Judith Legman, Don L. F. Nilsen, Victor Raskin, Elizabeth Reis, Martha Sachs, Christine Sundt, and Carol Tavris. We are grateful to Judy Chicago for allowing us to reproduce her lithograph, to Donald Woodman for photographing her work for the book, and to Jon Cournoyer for handling the arrangements. Our thanks also to Cyril Satorsky, John F. Waggaman, and Marian Henley for giving us permission to include their works in this book.

We would like to express our sincere thanks to Indiana University Press, especially Peter-John Leone, for encouraging us to pursue this book project, and Bobbi Diehl, our editor, who has been extremely helpful throughout this process, as well as Susan Havlish and Matthew Williamson. We would also like to thank the staff at Indiana University Photographic Services, particularly Sharon Leigh and Steve Weir.

Sex and Humor

The Kinsey Institute Collections

CATHERINE JOHNSON

Visitors to The Kinsey Institute are given a tour of the art gallery, where they are shown a small but varied display of paintings, prints, photographs, sculptures, and artifacts, each one carefully chosen to represent a particular aspect of the Institute's collection. Given that they have been invited into the *art* gallery, visitors are often surprised and delighted to find not only works by major artists such as Rembrandt, Hogarth, Matisse, and Picasso, but also an impressively mounted display of decorated condoms (figure 1) and an assortment of colorful ceramic ashtrays, salt and pepper shakers, nutcrackers, and playing cards, all commercially produced for the erotic novelty market. The staff member guiding the tour then explains that the founder of the collection, Dr. Alfred C. Kinsey, did not intend to create a museum of fine art. Rather, his desire for scientific discovery led him to assemble a large and diverse collection of "visual data" for research purposes. As a result, the art, artifact, and photo-

*Figure 1. UNKNOWN, UNITED STATES AND GERMANY
Condoms, 20th century
Latex, miscellaneous embellishments
4" x 2" x 2" to 13" x 3" x 3"
Multiple KI numbers
Donated 1946–1966

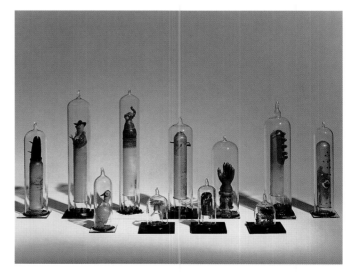

*Many of the items illustrated in this book were donated to The Kinsey Institute, and often little information exists about the identity of the artist, the date, or the country where it was produced. When known, the following information is provided for each piece from our collection: artist, country or area of origin, title or description (titles are in italics), date, medium or format, dimensions, Kinsey Institute collection number, and donation date.

graph collection that exists today provides scholars and other researchers the opportunity not only to see what well-known artists have created in the erotic genre, but also to study the more common and often humorous forms of erotica that people with modest incomes would have been able to acquire.

Alfred Kinsey was by nature a collector. As a graduate student and later as a professor of zoology at Indiana University, he traveled widely to collect gall wasp specimens in a determined effort to record every possible variation in the species.[1] By the time he was ready to write the definitive book on the subject, he had millions of wasps all neatly tagged with information about their individual characteristics. When he became interested in sex research in the late 1930s, he approached that subject with the same enthusiasm and intensity. He had been asked to participate in a team-taught course on marriage, and he became frustrated when students in the class began to ask him questions about sexual behavior for which he could find no accurate answers. He developed a detailed set of interview questions and began to collect sexual histories from his students at the university. Kinsey soon realized that he would need to find interview subjects with a broader range of sexual experiences than young college students, so he began to travel to Indianapolis, Chicago, New York, San Francisco, and other cities and towns in search of volunteers. By 1945 he had set a goal of interviewing 100,000 people about their sexual lives, in order to be certain that he had reliable scientific data on every form and variation of human sexual behavior.[2] He also began to acquire books and journals for his research library, as well as art and ephemera (some of which was given to him by his interview subjects). When the Institute for Sex Research was founded in 1947, Kinsey sold his collection to the Institute for one dollar.[3] The following year he published *Sexual Behavior in the Human Male,* a ground-breaking book that quickly became a bestseller and generated enough income in royalties to enable Kinsey to become a serious collector of erotica.

One consistent feature of the objects and images found at the Institute is the frequent association of humor with sexuality. From the beginning, Kinsey collected materials that used sex to make people laugh. One of the earliest items to enter the collection was "The Wonderful Sex Detector," a device made of plastic, string, and wood that had been purchased in a St. Louis joke shop. Other early acquisitions included several "man in a barrel" toys (the joke came when the barrel was lifted and the man's large penis popped into view) and a variety of articulated male and female figures, made of metal or wood, that appeared to copulate when moved back and forth. Among the many photographs that entered the collection were images that either were meant to be funny or just happened to turn out that way: women holding lit cigarettes or other unusual objects in their

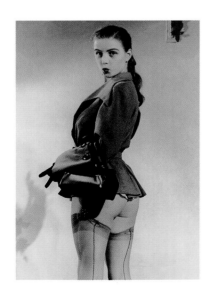

Figure 2. UNKNOWN, UNITED STATES
Office worker in garters, c. 1955
Gelatin silver print
3³/₄" x 2⁵/₈"
KI-DC: 12430
Donated in 1964

Catherine Johnson

vaginas, individuals inexplicably lacking significant articles of clothing (figure 2), scenes of group sex with the participants' arms and legs flung in every direction, penises posing as "sausages" on dinner plates, and countless examples of imaginative positions for a variety of sexual activities.

Kinsey did not limit his collecting to contemporary art and objects made in the United States and Europe. He wanted to be able to study sexual behavior and attitudes in many cultures, both present and past, so he tried to collect as broadly as possible. Artworks and artifacts—many of them humorous—arrived in Bloomington from around the world. Although it was beyond the means of the Institute to collect materials from every known culture or time period, the variety is impressive. A tiny carved ivory box from China features a man lying face down on the lid—when the box is opened, the man's face can be seen peering through a hole in the lid, while the lower half of the box contains a man and woman engaged in intercourse. From Mexico there are a number of plump ceramic chickens—when the bodies of the chickens are lifted up, one finds human male and female figures engaged in various forms of sexual activity. An engraved bookplate titled *La Petite jardinière* by the German graphic artist Michel Fingesten shows a nude woman watering a "penis tree" that has sprouted a number of penis-shaped branches (figure 3). A ceramic piece from Japan features a woman, dressed only in a red skirt that is open to reveal her genitalia, who is inserting a large, realistically wrinkled dildo into a gigantic vagina (plate 12).

The Institute's collections not only illustrate the significance of humor in sexual imagery around the world, they also provide visual documentation of the impact of the Kinsey reports on American culture. The publication of *Sexual Behavior in the Human Male* and, in 1953, the follow-up volume *Sexual Behavior in the Human Female* inspired numerous cartoons, parodies, greeting cards, and novelty items (plate 1). Manufacturers of birthday cards used Kinsey's name to make veiled references to sexuality—"You think you're getting old and flimsy? That's not what I heard from Dr. Kinsey" declares one such greeting. A small humor book titled *The Whimsey Report; or, Sex Isn't Everything* appeared in 1948, just months after the *Male* volume was published, and the release of the second book inspired additional humor publications, including *The Flimsey Report* and *Oh! Dr. Kinsey! A Photographic Reaction to the Kinsey Report*.[4] The latter features questions that were supposedly taken from a Kinsey interview; each question is accompanied by a photograph of a woman's face showing her exaggerated expression as she reacts to it. Sometimes Kinsey's name was slightly misspelled, possibly to avoid legal problems—a small pamphlet in the Institute's collection is titled *What You Can Do about Sex after 60 According to the Latest Kinsee Report* (the joke being that all the pages are blank).

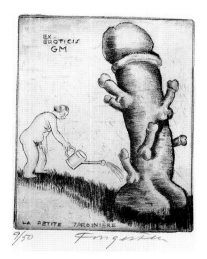

Figure 3. MICHEL FINGESTEN (1884–1943), GERMANY
La Petite jardinière (bookplate for Gianni Mantero), 20th century
Engraving
6¹/₈" x 5" (plate)
A402R F4973.41
Donated in 1981

The pieces selected for the exhibition and for inclusion in this catalog represent just a small portion of the Institute's collection of art, artifacts, books, and photographs that could be considered humorous. One challenge that has faced those of us involved in organizing this exhibition has been deciding what should be included, as everyone has a different opinion about what is and is not funny. It is our hope that this exhibition and the essays featured in this catalog will serve as catalysts for further discussion about the nature of humor and its relationship to human sexual behavior and expression.

<div style="text-align: right">

Catherine Johnson
Curator of Art, Artifacts, and Photographs
The Kinsey Institute

</div>

NOTES

1. Dr. Alfred C. Kinsey began teaching at Indiana University in 1920, and he remained at the university until his death in 1956. His career as a sex researcher did not begin until 1938, and in 1940 he gave up teaching in order to devote his time to research.

2. Kinsey announced his intention to collect 100,000 sexual histories to the National Research Council in 1945; he expected it would take twenty years to complete the work (Jonathan Gathorne-Hardy, *Sex the Measure of All Things: A Life of Alfred C. Kinsey* [Bloomington: Indiana University Press, 2000], p. 231). When he died in August 1956, he and his research team had conducted more than eighteen thousand interviews. Although this fell considerably short of his goal, the information that Kinsey collected allowed him to write his two landmark volumes, *Sexual Behavior in the Human Male* and *Sexual Behavior in the Human Female,* both published by W. B. Saunders, Philadelphia. The data is still used by researchers today.

3. The Institute for Sex Research was renamed The Kinsey Institute for Research in Sex, Gender, and Reproduction in 1982.

4. The following books are in the Institute's library and are featured in the exhibition: Parke Cummings, *The Whimsey Report; or, Sex Isn't Everything* (New York: Thomas Y. Crowell Company, 1948); *The Flimsey Report* (Farrell Publishing Company, 1953); Lawrence Lariar, *Oh! Dr. Kinsey! A Photographic Reaction to the Kinsey Report* (New York: Cartwrite Publishing Company, 1953).

Sex and Humor:
A Personal View

JOHN BANCROFT, M.D.

In my last year at boarding school, aged around seventeen, finding myself uncharacteristically performing on stage, I discovered that I could make people laugh. My father owned a theater, so as a child I'd always assumed my role in school productions to be stage manager rather than performer. Yet during my school holidays I had spent an inordinate amount of time standing on the steps of the dress circle in my father's theater listening to stand-up comics and watching pantomime dames. Maybe I'd absorbed something. From then on I took what opportunities I could get to be funny, and I have remained intrigued by what makes people laugh. I'm in good company; that fascination has been shared by philosophers from Plato and Aristotle through Hobbes, Voltaire, Kant, Schopenhauer, and Bergson; and by scholars such as Darwin and Freud, Koestler, and many more.

In the past thirty years or so theories and psychological experiments on humor have multiplied and produced a growing literature. In 1976 I attended the first International Conference on Humour,[1] in Cardiff, Wales. I came away thinking that I should stop trying to understand humor, or in the process I might lose my sense of it. Why I have not had the same concern about studying sex escapes me. There have now been nineteen such conferences; somehow humor, as a scientific concept, remains as elusive as ever.

This book is about sex and humor, and there are some interesting parallels between them. Both are enormously important aspects of the

human condition, yet neither, for one reason or another, is taken seriously by the academic world. As we learn more about sex, so it grows more complex and more difficult to understand. Perhaps we can afford to remain mystified about humor; with sex the associated problems are so enormous that we have to make an effort to understand it, at least in order to lessen those problems. But we should not underestimate the problems associated with humor. The various ways in which it can be used as a form of social control, as of women by men and of sexual and racial minorities by majorities, should cause us concern and at least make us more aware of its negative consequences.

So what is humor and why do people laugh? It seems obvious to me that we are talking about something very basic and fundamental which, like sex, has been complicated by the machinations of the human mind. Some see humor as a uniquely human phenomenon. I don't agree. Recently I attended a reception at the Cleveland Zoo. The fact that it was part of the annual meeting of the Society for Impotence Research is irrelevant. Before the meal we wandered through the indoor areas. The high point was a group of about twenty of us in fits of laughter at the behavior of an orangutan. This deadpan orang was clearly playing to the audience, but he was hilarious. Eugene Linden[2] tells a number of stories of zoo animals playing pranks and being funny: orangutans, polar bears, wolves, goats, chimpanzees, leopards, gorillas, killer whales, dolphins, and parrots, among others. How much this is something they learn to enjoy in captivity is not clear. But captivity, at least for us humans, is not exactly a recipe for humor.

Darwin saw smiling and laughter as basically expressions of joy, manifested clearly in the child and often in the mentally handicapped older person.[3] Babies laugh at a very young age, at games such as peek-a-boo, well before they have any comprehension of language. This simple, primitive humor of the infant gradually becomes more sophisticated with cognitive development. Before we laugh we often smile. Smiling powerfully bonds the infant and mother. Both smiling and laughter also have clear social bonding functions when we are older. We don't smile only when we are amused; both smiling and laughter seem to be expressions of some underlying positive mental state.

Recently the study of how our brains work has entered a new and exciting phase with the development of brain imaging techniques. These allow us to identify areas of the brain that become activated during different types of mental activity. Specific brain areas have now been identified as activated during the experience of humor.[4] We should not, however, repeat the mistakes of the phrenologists and expect to find that the results of such studies will be neat and tidy, fitting comfortably into our preexisting conceptual systems. We have already learned how non-specific are

John Bancroft, M.D.

many brain mechanisms, playing a part in a variety of experiences which we think of as distinct but which obviously have certain neurophysiological characteristics in common. Thus what we regard as humor is likely to involve some of the same brain mechanisms that are involved in other pleasurable experiences, including sex. The challenge is to understand how, in terms of brain function, these pleasurable experiences differ. In a recent French study of brain imaging during sexual arousal, humorous stimuli were used as a form of "control" for positive, rewarding experience—and, sure enough, some of the brain areas activated during sexual arousal were also activated during humor.[5]

The relationship between humor and mood is also interesting. Whereas we tend to find things less funny when we are depressed, in states of abnormally elevated mood—hypomania or mania—we are too easily amused, often indulging in exaggerated semantic tricks, free associations, and "knight's moves in thought." In dealing with the more normal vicissitudes of life we often use humor to improve our mood.

In the history of this topic a variety of theoretical explanations have surfaced. These have been usefully reviewed by Raskin[6] and also by MacHovec.[7] What I find interesting about this literature is that each theoretical model seems to account for only part of what we generally regard as humor, and furthermore each approach seems to reflect the theorist's personal style of or attitude toward humor: it is almost a value system rather than an objective intellectual analysis. I have already revealed in this essay my preference for viewing humor as something primitive and positive, a simple expression of joy in the infant which becomes more complex as we get older: Darwin drew the analogy between tickling the body, which makes us laugh in almost reflex fashion, and "tickling the imagination with a ludicrous idea." The theoretical approach that probably takes us closest to this basic mechanism sees laughter as the response involved in the release of pent-up tension, with humor the mood state associated with this release. According to this "arousal/safety" theory, humor comes in when we are aroused by something and then realize that there is no cause for concern. The laughter of the baby in response to "Peek-a-boo!" can be understood in these terms; the merriment of children at Halloween is a further, more developed example. The "ludicrous idea" that Darwin referred to allows a development of that theme: in some cases the ludicrousness derives from the realization that what was initially scary is in fact not scary at all. But this type of cognitive appraisal can be extended so that neither scariness nor arousal is necessarily involved, but rather a recognition of incongruity and then awareness of its resolution. We respond to the semantic playfulness of the joke with increasing cognitive sophistication as we get older. Here the more semantic theoretical approaches of Raskin and others come into focus. I feel comfortable with all that, and I can see how

each explanatory model can contribute to a developmental approach to humor. What I find more challenging, and more troubling, is the strong tradition of humor theory, dating back to Plato but with many more modern proponents, which emphasizes disparagement, the use of humor to demonstrate superiority or control over another person. Some theorists see humor as a mechanism for defusing anger or aggression. I'm well aware of the fact that a great deal of humor disparages someone. My question is whether this is an essential component of humor or rather a particular application of it. And if the latter, is this a reflection of the personality of the humorist, or his or her particular social situation, or perhaps a combination of the two? In my humble attempts to be a comedian I feel much more comfortable making people laugh at me than at someone else. And if I involve other people in my humor, then I prefer them to be present and able to enjoy the humor with the rest of us. I feel uncomfortable making jokes about particular categories of people, such as women, gays, or the Irish; the one exception might be those who take themselves too seriously. This issue of taking ourselves too seriously is central to my views about sex and humor, which I will expand on later in this essay. However, I am a privileged white male. If I were a woman or black or gay, I might want to use humor as a political tool along the lines that Leonore Tiefer so well describes in this volume.

Then there is the elusive quality of "a sense of humor," which some people have much more of than others. Is this just a matter of greater aptitude for the recognition of incongruity? Timing seems to be important. Two people may tell the same joke, and one is much funnier in the telling because of some element of timing—bringing in the punch line at the right moment for the incongruity to have built up, perhaps. Quickness is another asset. Being able to spot the incongruity and refer to it is at the basis of much spontaneous humor, the type that typically characterizes the funny person. Spontaneity itself introduces another interesting dimension. Humor can be roughly divided into "jokes," which are in some sense "canned" and reproduced periodically, and "situations," which are spontaneously interpreted as humorous by someone with the requisite quickness of wit. I aspire to be spontaneously funny, although if I am preparing myself for a comic performance I spend a great deal of time planning what I am going to say; I certainly can't rely on being "spontaneous on the night," but I strive to convey an aura of spontaneity, rather than a series of "do you know the one about . . . "; yet I would never expect anyone else to repeat what I say. Curiously, I am particularly bad at remembering other people's jokes, even though I may laugh at them when I first hear them. What do these differences in how people use and respond to humor tell us? Do they illustrate different functions of humor, or different types of personalities among those who use it, or perhaps different "cognitive styles"?

John Bancroft, M.D.

We also need to consider the medium used to convey humor. This book is principally about amusing images in the Kinsey Institute collections. Such images have a permanence which precludes spontaneity, yet they vary in how subtly their humor is conveyed. The funniness of many of the examples here will depend on how the viewer perceives them. Yet my favorites make me smile whenever I see them, which cannot be said for many "canned jokes," which, in my case, lose a great deal after the first hearing. I often wonder why people put jokes on bumper stickers—are they simply aiming to amuse those who see them for the first time, or do they themselves enjoy the joke each time they look at their bumper? The "eight-pagers" that Frank Hoffmann describes in this volume are examples of the "cartoon" mode, in which old jokes are delivered in a variety of new versions, involving either familiar cartoon characters or well-known "real" people. Often in such circumstances the humor depends on this novel or ingenious twist in characters or context rather than on the original joke. Spontaneous humor can rely on such devices.

So why does so much of humor have a sexual theme to it? A great deal of sexual humor meets the criteria for disparagement. A lot of jokes are by men at the expense of women. In recent years we have seen women's response: jokes by women at the expense of men. Leonore Tiefer gives us examples of feminist humor. There are jokes about gays and lesbians, and again, in riposte, we find gay and lesbian comedians defusing the theme by making jokes about themselves as well as about the straight world. Many jokes disparage the sexual competence or performance of particular individuals. We have recently been through another epoch—there are many others in history—in which the sexuality of politicians was the target of disparaging humor.

Mikita Brottman tells us in this book about the work of Gershon Legman, one of the leading chroniclers of the "dirty joke." Legman not only subscribed to the "disparagement" theory of sexual humor, he also emphasized an "anxiety-reduction" component, arguing that many, if not most of us are scared by or uncomfortable about sex and use humor as a way of reducing those anxious feelings. Interestingly, Mikita Brottman, in her analysis, suggests that Legman's own anti-homosexual prejudices, which could be regarded as homophobic, exemplify a link between the disparagement and anxiety-reduction functions. Certainly Legman's work puts sexual humor in a negative light. I prefer a more positive perspective, no doubt revealing in the process some fundamental differences in our two personalities.

The aspect of sexual humor which I most enjoy and feel most comfortable with is the essential funniness of human sexuality—and that means the sexuality of all of us. This is humor about absurdity and the absurdity of the sexual act as carried out by human beings. There are many variations

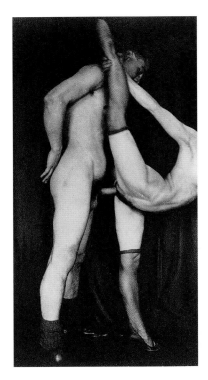

Figure 1. **UNKNOWN, UNKNOWN**
Man and woman in coitus
(acrobatic pose), c. 1945
Gelatin silver print
5³⁄₈" x 2⁷⁄₈"
KI-DC: 8344
Donated in 1964

Figure 2. **UNKNOWN, GERMANY**
Couple in the grass (from album of
drawings), c. 1850
Graphite
7¹⁄₄" x 9³⁄₈" (9¹⁄₄" x 12³⁄₄")
A402Q A007
Donated in 1977

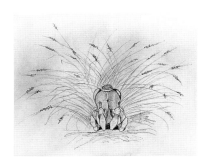

on the sexual act in the human repertoire, more than there are for any other species. But the basic human sexual act, copulation, is fundamentally the same as the sexual act of most other mammalian species. So it is absurd because we like to see ourselves as not only superior to all other species, but also fundamentally different from them. This absurdity is captured in the quintessentially American debate over the teaching of evolution or creation in schools. If God made us all in seven days, then he clearly didn't have enough time to think of a different and more suitably dignified system for us humans to reproduce ourselves. And I thank God for that, because I see this absurdity as part of our salvation—salvation from the appalling consequences of taking ourselves too seriously. How can you really take yourself seriously when you engage in sexual activity?

This absurdity strikes me at two levels. The first is the sexual interaction between two people. The wonderful incongruity of the woman in an aesthetically as well as athletically impressive pose while sexually coupled (figure 1), contrasted with the basic and mundane coupling in the grass, given away by two pairs of feet (figure 2); the ridiculousness of the couple who did not have time to get undressed (plate 25); the bespectacled woman distancing herself from the absurdity by reading a novel, or possibly a cookery book, as if waiting for the dishwasher to complete its cycle (plate 26); the numerous artifacts in our collection that, by means of articulated paper, wood, or metal, allow the copulatory motion to be demonstrated with monotonous repetitiveness; all are examples of joyful absurdity.

The second level of sexual humor focuses on the absurdity of the human genitalia. Here the male is at a distinct disadvantage. Set against all our sophisticated criteria of male beauty and beautiful male power, the male genitalia are in ridiculous contrast—most particularly when the penis is erect, and regardless of its size, large, medium, or small. This is well captured in the image of the beautiful male form, reclining against the classical column, made incongruous by the erect phallus (figure 3). Demonstrating perhaps what psychoanalysts describe as "reaction formation," men through history have glorified the phallus in a variety of ways. But they have also ridiculed it. The Kinsey Institute collections abound with examples of phallic absurdity, some of which appear in this book: the phallus as some form of separate individual, usually either subservient or pompous (plate 31), a ballistic weapon of war (plate 39), a reptile under the influence of the snake charmer (plate 30), a delicious variant of the sausage (figure 4), a fishing rod (plate 28), an enormous appendage requiring a wheelbarrow for transport (plate 36—this image crops up innumerable times), and my favorite, a rabbinic highway for snails into outer space (plate 27).

For the female the absurdity is more subtle, and unfortunately we have far fewer depictions in our collections. The theme is usually the mys-

John Bancroft, M.D.

tery of this "inner sanctum"—the idea that we might be swallowed up by or at least disappear into this magical space is captured by the image of Lilliputian figures (plate 40) or mice (plate 42) timidly exploring the threshold. There is Hans Bellmer's elaboration of a vulva into a somewhat mysterious woman (plate 41). Needless to say, these depictions are by men. Humorous images of women's genitalia portrayed by women are hard to find. Judy Chicago provides us with a rare example (figure 5), which significantly expresses the "free flight" of the vagina, as if to emphasize its independence from the status of receptacle imposed by men. But things seem to be changing. The notable and accelerating popularity of the *Vagina Monologues,*[8] a stage presentation of statements by women about their vaginas, indicates an interesting and potentially important phase in feminist humor. The combination of hilarious humor and serious comment about the sexual exploitation of women by men is striking. Much of the humor reflects the absurdity of society's requirement that this fundamental aspect of womanhood, both sexual and reproductive, be denied, hidden, and felt as shameful. The use of humor to deconstruct social embarrassment is especially effective, and here we are seeing such humor moving into the mainstream.

Then we have scatological humor (from the Greek *skatos,* "dung"). Here God's seven-day plan certainly left us with a formidable problem—the close juxtaposition or, in the case of the penis, incorporation of our reproductive and excretory functions. Excretion is another challenge to our status as dignitaries. Not quite so with urination; the graceful arc of a stream of urine can have aesthetic appeal, which is often captured in landscape sculpture (plate 20), though here it is women who are somewhat at a disadvantage. But defecation defies aesthetic depiction, whatever way you look at it, and most people prefer not to. We have a long way to go before we can dispense with our bodily waste in visually appealing recyclable containers. There are many people who find defecation more absurd (and embarrassing) than they do sex. And the sexual connotations of the anal passage ensure an overlap between sexual and scatological humor. But once again we can be funny without having to be disgusting, to contrast with Legman's "really filthy" jokes, and the image of a man and woman perched upon the same chamber pot is a good example (plate 21).

While advocating a positive approach to sexual humor, it is sensible to acknowledge that if we find sex too funny it may become a barrier to the other rewards which it is well designed to provide. I encounter this issue from time to time as a sex therapist. One partner in a sexual relationship may engage in so much humor about their sexual activity that it detracts from sexual pleasure, and perhaps more particularly, sexual intimacy. Obviously in some such cases the humor is a way of dealing with anxiety or tension, echoing Legman's analysis, and the therapy then needs to look behind the humor to deal with the anxiety. But a balance between aware-

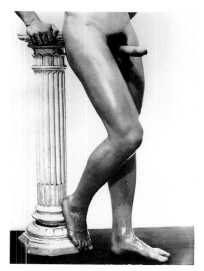

Figure 3. UNKNOWN, UNITED STATES
Man with erection leaning on column, mid–20th century
Gelatin silver print
7" x 4⅞"
KI-DC: 32101
Donated in 1958

Figure 4. UNKNOWN, UNKNOWN
Penis as food, c. 1920
Gelatin silver print
5¾" x 4⅛"
KI-DC: 44723
Donated in 1950

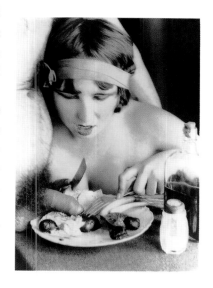

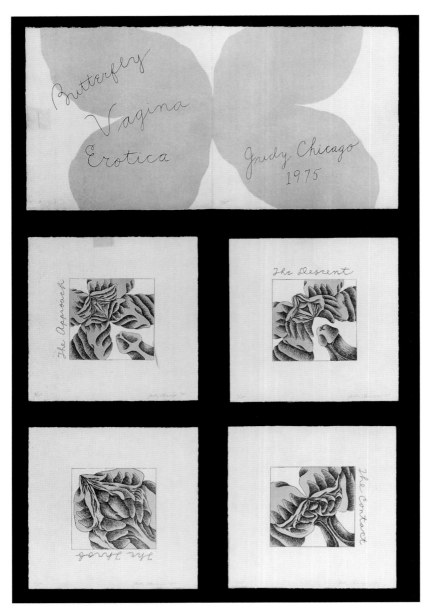

Figure 5. JUDY CHICAGO (1939–),
UNITED STATES
Butterfly Vagina Erotica, 1975
Lithograph
42" x 32" (framed)
Collection of the artist
Copyright © Judy Chicago 1975
Photograph © Donald Woodman

ness of absurdity and enjoyment of sexual intimacy is a worthwhile aim. In my value system, one of the most important benefits of a good sexual relationship is the fostering of sexual intimacy, that special closeness unique to that relationship. And that intimacy depends in large measure on the fact that both partners are making themselves vulnerable and remaining emotionally secure in the process. Such vulnerability also derives in no small measure from the absurdities of our sexual interactions. We need to feel emotionally secure before we can behave like that in front of another person. But at the appropriate time we should at least be able to smile!

NOTES

1. Anthony J. Chapman and Hugh C. Foot, eds., *It's a Funny Thing, Humour* (Oxford: Pergamon, 1977).

2. Eugene Linden, *The Parrot's Lament: And Other True Tales of Animal Intrigue, Intelligence, and Ingenuity* (New York: Dutton, 1999).

3. Charles Darwin, *The Expression of the Emotions in Man and Animals,* authorized edition (New York: Philosophical Library, 1955).

4. Dean K. Shibata, presentation at the 86th annual meeting of the Radiological Society of North America (RSNA), Chicago, November 2000.

5. J. Redouté, S. Stoleru, M.-C. Grégoire, et al., "Brain Processing of Visual Sexual Stimuli in Human Males," *Human Brain Mapping* (in press).

6. Victor Raskin, *Semantic Mechanisms of Humor* (Dordrecht, Holland: Reidel, 1985).

7. Frank J. MacHovec, *Humor: Theory, History, Applications* (Springfield: C. C. Thomas, 1988).

8. Eve Ensler, *The Vagina Monologues,* revised edition (New York: Villard, 2001).

Humor in the Eight-Pagers

FRANK A. HOFFMANN, PH.D.

The past century saw the newspaper comic strip grow from an occasional cartoon, usually tucked into the sports or political pages, to one of the primary vehicles of American humor. It first appeared in its present form in the late 1890s, and it quickly caught the fancy of the newspaper-reading public. The first comic strips were aimed at adults, for the most part presenting characters and situations of horseracing, boxing, and other sports. Sex, too, entered early, for many of the male characters indulged in flirting, and some were unabashedly woman-chasers. Such were the beginnings of strips such as *Mutt and Jeff, Barney Google, Joe Jinks, Bringing Up Father,* and most especially *Moon Mullins.*

However, editors soon became aware that comic strips had a great appeal for children, and they urged cartoonists to create new strips or modify existing ones so that they would have broader family appeal. A few such strips had appeared early, notably *Little Jimmy, Little Nemo in Slumberland,* and *Buster Brown.* Others soon followed, and with them came a focus on "real" people and situations. This new emphasis gained wide popularity among readers, who took the characters to heart, ensuring long runs for the strips. *Gasoline Alley* and *Winnie Winkle,* for example, are well over eighty years old and are still drawn today.

But the new focus did not eliminate sex. During World War I and the ensuing years an increasing number of women entered the workplace. Cartoonists saw possibilities there, and before long a new genre of comic

strip, that of the working girl, was born. Almost without exception, these secretaries, clerks, and salesgirls were attractive, and most were flirtatious. On the surface, all was innocent, but there was a strong undercurrent of sexuality. Often they were dressed in low-cut blouses or form-fitting sweaters, and they were frequently backlighted, so that shapely legs could be seen through thin skirts and dresses.

With the 1930s came yet another facet of sexuality in comic strips, the voluptuous female, usually clad either in slinky dresses or in minimal clothing. Although most often appearing in adventure strips such as *Terry and the Pirates, Flash Gordon,* and *Smilin' Jack,* she also turns up in straightforward humor strips, such as *L'il Abner, Alley Oop,* and *Abbie and Slats.*

Enter the eight-pager! Its precise origins—who created the first one, and where and when it was published—in all probability will forever remain a mystery. No genuine artist's name, publisher, place of publication, or date ever has appeared on one. Rather, we are given punning names, such as "Les Dooit," "Bendova Mary," "Ophelia Pratte," "Lotta Tocas," and "O. Watta Panzi." London and Havana are frequently given as places of publication, but there is not the slightest evidence that either was the source of even one eight-pager. Despite the fact that eight-pagers are often called "Tijuana Bibles," it is not likely that they were actually published south of the border.

In any event, sometime about the end of the 1920s or the very early 1930s the first eight-pagers made their appearance. They were small booklets, measuring approximately four and a half inches horizontally and three inches vertically. Some contained eight leaves printed on one side, while others consisted of four leaves printed on both sides. Hence the designation "eight-pager," for both formats had eight printed pages. They were printed on cheap newsprint paper and encased in a cover of equally cheap heavy paper or light cardboard. The cover carried a title and sometimes, as mentioned above, punning credits. Many also offered a sketch or sketches of the chief character or characters, ranging from simple head sketches to full-body action drawings.

That physical format remained the standard during the approximately three decades that the eight-pagers thrived. Occasionally, one might appear in a slightly larger format or with ten, twelve, sixteen, or even more pages, but such departures from the basic format were relatively few, and for the most part appeared later. They usually contained more printed text and presumably were trying to compete with the inexpensive paperback erotica that became available on the open market in the late 1950s.

The eight-pagers appear to have been distributed, at least up to the time of World War II, largely through venues whose clientele were predominantly male: barber shops, bowling alleys, barrooms, tobacco shops, and the like. With the onset of World War II and the appearance of mil-

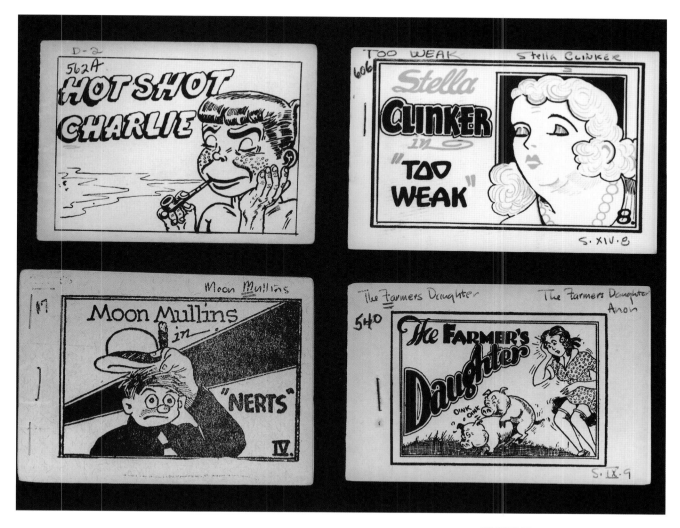

UNKNOWN, UNITED STATES
Eight-pagers, 20th century
Printed comic books
3"–3 1/8" x 4"–4 1/2"
Kinsey Library 17, 540, 562A, 606
Donated 1947–1962

lions of servicemen as potential customers, distribution expanded. I came of age during the war and served in the United States Navy, and I can recall seeing them behind the counter at magazine stands in railroad and bus terminals, in penny arcades, and in dusty little second-hand bookshops. During their last years of production, the late 1950s and early 1960s, the little second-hand book and curio shops seem to have been their primary distribution outlets.

When the eight-pagers first appeared, their creators naturally looked first to comic strips for inspiration. They used the same format, a sequence of panels presenting a brief narrative; the comic strip characters were easy to draw and familiar to readers; and in many instances little change was needed to make the characters vehicles of erotic humor. Everyone in the *Moon Mullins* strip exuded lechery; the youthful Skeezix of *Gasoline Alley* was developing an interest in girls and could easily be made to begin experimenting sexually; Jiggs did not escape to Dinty Moore's tavern just to eat corned beef and cabbage; and surely those many attractive and often

flirtatious working girls did not go home to spend the evening knitting socks. Indeed, many comic strip characters made a very smooth transition to the overtly erotic situations created for them by the eight-pager artists.

However, it did not take long for the eight-pager to expand its horizons. Motion pictures were as much a part of American popular culture as comic strips, and before the movie industry was a decade old sexual scandals and escapades had become a fixed part of the public's perception of it. It was a readymade scenario, and the eight-pagers exploited it fully. Once the doors were opened to real people, everyone and anyone became fair game: sports figures, politicians, socialites, gangsters, labor leaders, and more. An assortment of generic figures also emerged, including the bellhop, the salesman, the iceman, and the repairman.

Nevertheless, despite the multiplicity of real people portrayed in the eight-pagers during their heyday in the 1930s and 1940s, comic strips remained their primary inspiration. At least two-thirds of The Kinsey Institute's collection of more than a thousand examples make use of comic strip characters. Nor should that be surprising, for comic strips were created to amuse, and as blatantly erotic as the eight-pagers are, their main function is amusement.

In their efforts to achieve that end, the eight-pager artists gave free rein to their imaginations and tapped almost every conceivable vein of humor. We find deception, word play, comic misunderstandings, the insatiable female, the inexhaustible male, the inadequate male, reversals of fortune, social satire, political satire, ethnic jokes, ingenious seductions, stereotypes of all sorts, and much, much more. Story lines are minimal; often they are nothing more than incidents following upon some simple motivating action. Occasionally, a story is carried over into a second or third eight-pager, but such extended narratives are rare. Many eight-pagers are built around jokes, some of which have circulated for generations. These mini-narratives, jokes, and incidents are often repeated, with slight variations, using different settings and characters. The following examples are but a modest sampling of the forms of humor to be found in the eight-pagers.

In an eight-pager titled "Nerts," Moon Mullins is a store clerk. A young lady comes in and asks if he has Lifebuoy (a popular brand of soap in the 1930s and 1940s). He replies that he certainly has and takes her into the stock room, where he has intercourse with her. At first she objects, but when he is finished, she says that if he will give her the soap, she will be back tomorrow with another order. The humor is a play on words: her question, "Do you have Lifebuoy?" is interpreted by Moon as "Do you have life, boy?" (implying sexual ability).

In "Victory and Rape," we have a combination of political satire and double entendre. In China, the Communists are defeating the Nationalist

Frank A. Hoffmann, Ph.D.

army and are raping their women, who do not object. An aide informs Chiang Kai Shek of the situation, and Chiang observes that at least Madame Chiang is safely locked away in their shack. The last panel shows a naked Madame Chiang confronted by "Uncle Joe" Stalin, who is pushing his huge penis into her and telling her that she is about to be fucked by the biggest prick in Russia.

Eight-pagers often borrowed from the large cycle of traditional jokes about the salesman and the farmer's daughter. In one titled simply "The Farmer's Daughter," a salesman's car breaks down and he asks a farmer to put him up for the night. The farmer says that he and his daughter share the bedroom. The daughter has her own cot and the salesman must share the bed with the farmer. During the night, the daughter comes to the bed and initiates intercourse with the salesman, at the same time pulling a hair from her father's backside to make sure he is asleep. As she and the salesman have extended sex, she continues to pull a hair from time to time. Finally, the farmer tells them to fuck and stop keeping score with his ass or he's going to raise hell.

In a variation on the theme, titled "T'ain't Loaded," the farmer has three daughters. He gives the salesman a separate room and warns him that if he is caught screwing the girls, he'll blow his ass off with his shotgun. At 10:00 P.M. one of the daughters comes in looking for sex. She assures the salesman that the shotgun isn't loaded, whereupon they have sex for several hours. At 2:00 A.M. the second daughter comes in, also assuring him that the gun isn't loaded. He manages to satisfy her sexual desires, but by the end of their session, he is exhausted. When the third daughter arrives at 4:00 A.M., he tells her that his gun isn't loaded either.

Another recurring theme is progressive seduction. In some examples it serves merely as a means for the parties to obliquely initiate the sexual activity they both desire, without bluntly getting to the point. In others, the humor comes as a surprise twist at the end, as in "Too Weak." Stella Clinker, a character in the *Toots and Casper* comic strip, goes to the dentist to have a tooth extracted. After giving her gas, he, step by step, plays with her breasts, undresses her, and has her fellate him, at each step asking if she knows what he is doing. Each time she replies, "Yes, but I'm too weak to stop you." However, when he begins intercourse and again asks the question, her reply is that he's getting a swell dose of clap but she's too weak to stop him.

The same basic story appears in "I Said It and I'm Glad," featuring the title character from the comic strip *Penny*. A male acquaintance calls to Penny from his car, asking why she called his friend Joe a son of a bitch. Penny offers to tell him if he will give her a ride. As they ride along, he makes advances to Penny. She says that first Joe felt her tits, like he's doing, and the reply is that that's no reason to call him a son of a bitch. The

seduction continues, with the friend parking the car, taking Penny into the bushes, removing her clothing, having intercourse with her, and having her fellate him. With each step of the seduction, she says that that's what Joe did, and his response is that that was no reason to call him a son of a bitch. Finally, as he is performing cunnilingus on her, she remarks that when Joe was doing that he told her that he had the clap. The friend's head jerks up and he exclaims, "Why that dirty son of a bitch."

Other eight-pagers drew on real life. In 1926, the wealthy eccentric Edward Browning caused one of the many scandals which shook American social circles during the Roaring Twenties when he married Frances Heenan, a stereotypical gold-digging flapper. The press referred to him as "Daddy" Browning (after "sugar daddy," a contemporary term for a wealthy man who squanders money on young women of questionable character), and dubbed her "Peaches." It was perfect grist for the eight-pagers' mill, and several "Daddy" Browning and "Peaches" booklets appeared during the years following the event. In them, Browning was characterized as the inadequate male and "Peaches" the sexually insatiable female.

In "My Kingdom for a Horse," which purportedly takes place before their marriage, Browning sees "Peaches" while out driving and invites her to accompany him. He tells her that if he can't satisfy her, he will buy her a Rolls Roice [sic]. They park out in the country, where he does his best, but she remains unsatisfied. He rents a horse at a nearby farm, and the animal's huge penis does satisfy her. He says he will buy her the Rolls Roice, but she tells him to buy the horse instead, for she can't fuck a car.

In "Peaches and Cherries" we are given a very similar theme. The two are presumably now married, and in the morning, "Daddy" calls "Peaches" to show her his almost erect penis. However, he is still unable to perform to her satisfaction. After he leaves for the office, she checks out the iceman's penis. That, too, is unsatisfactory, and she tells him to send up his horse. The animal satisfies her needs, but ultimately collapses in exhaustion, leaving her in tears.

Although it is usually a female who is portrayed as insatiable, males, too, occasionally are characterized as insatiable, or perhaps inexhaustible. In "Hot Shot Charlie," Charlie, a character in the *Terry and the Pirates* comic strip, brags to a friend about having had eighteen sexual encounters in a row. A girl overhears him, and neither she nor the friend believe him. He bets the girl one hundred dollars that he can do it, and she takes him up on it. As they begin, the girl says she will keep score with chalk marks on the head of the bed. An hour later, Charlie is still spry after six times. After two hours, he remarks that this thirteenth is as good as the first. The girl says that it's only the twelfth. To her consternation, Charlie rubs out all the marks and says they can start over.

Keeping score is another recurring theme, but it is not always a way

Frank A. Hoffmann, Ph.D.

of establishing bragging rights. In "Maggie's Vacation," featuring Maggie and Jiggs from the comic strip *Bringing Up Father,* Maggie goes on vacation, leaving Jiggs to fend for himself. He hires a burlesque girl to cook for him. She burns the food, but that does not bother Jiggs, for he is only interested in sex with her, which he engages in repeatedly, wearing the poor girl out. At this point, Maggie returns and catches them. She makes them continue their lovemaking, keeping score on the wall, until Jiggs is worn out. After fifty-two times, he can no longer continue, whereupon Maggie knocks him out with a rolling pin and then calls an ambulance. In the hospital, a nurse tries to seduce him, but Jiggs is not at all interested. We might take note of the fact that this eight-pager was copied at least twice. In one copy, Maggie makes thirty-seven marks on the wall before Jiggs gives out, and in the other, he makes it only to twenty-nine.

It should be almost unnecessary to add that the all-time champion inexhaustible male of the eight-pagers is Popeye, but of course, he had the unfair advantage of being fortified with spinach!

The eight-pagers were produced for approximately thirty years, from about 1930 to about 1960, give or take a year or two at each end. I can recall seeing what appeared to be new copies being sold as late as the middle 1960s, but I'm quite certain that they were either reprints or back stock which the sellers had on hand, for the characters which appeared in them belonged to a much earlier era. One example sticks in mind, for it featured Rosie and Archie from the comic strip *Rosie's Beau,* which was dropped from the comic pages in 1944.

The heyday of the eight-pagers was the 1930s and 1940s, when such inexpensive erotica ideally suited the slim purses of the general public during the Depression era and those of servicemen during World War II. There probably was some resurgence in the early 1950s, during the Korean War, but that was the eight-pagers' last hurrah. By the late 1950s and early 1960s, greater permissiveness in the publishing industry resulted in the appearance of more sophisticated erotica in inexpensive paperback formats. During this period, some booklets similar in appearance to eight-pagers but in a slightly larger format and containing more pages were published. They combined a series of drawings in comic strip style with printed text. They were intended to appeal to the eight-pager audience, but they lacked the concise, direct sexual punch of the eight-pager and did not last long.

Today, the eight-pager lives only in the older generation's nostalgia. Although some of the comic strip characters would be familiar to modern readers—Blondie and Dagwood, Popeye, Jiggs and Maggie, Skeezix, and a few others—many more have long since disappeared from newspaper pages—Moon Mullins, Pete the Tramp, Mutt and Jeff, Polly and her Pals, Ella Cinders, Little Annie Rooney, Dumb Dora, and countless others. Some

of the names might be familiar, but few modern readers would know the types of characters they were.

Much the same holds true for the real people who appeared in the eight-pagers. Certainly, Joe Stalin would bring a clear picture to anyone's mind, as would Joe Louis, Babe Ruth, Lou Gehrig, Joan Crawford, the Marx Brothers, Bing Crosby, and Greta Garbo, all of whom made appearances in the eight-pagers. But how many today could identify Daddy Browning and Peaches, Joe Penner, Olga Baclanova, Wheeler and Woolsey, Jim Londos, Barbara Hutton, Jon Hall, or Sonja Henie? In all probability, very few under the age of sixty.

To sum up, the eight-pager was very much a product of its time, and to gain full appreciation of its humor one must have some understanding of the people and events of that long-past era. The characters depicted, both the real people and those derived from comic strips, exhibit customs, manners, and personality quirks that often differ from those found in modern society. Even their language is peppered with slang that is no longer used. A traditional joke about generic characters such as the salesman and the farmer's daughter or the dentist and his semi-conscious patient may still elicit chuckles, but specific characters, whether real or comic strip, present distinct personalities that react and interact as dictated by their individual sets of values. In short, it comes down to how and why the characters think and act as they do.

A good illustration is the eight-pager titled "Mary Livingstone Hocks Her Benny," featuring Mary Livingstone (wife of Jack Benny) and Bing Crosby. The story is simple. Jack Benny is in hock (the reason is not given) and Mary must get him out, but she has no money. Bing Crosby suggests she sell sex. She tries it with him and decides that she likes it. I suspect that most modern readers would find little humor in the episode. They probably would recognize Bing Crosby's name, possibly Jack Benny's, and almost certainly not Mary Livingstone's. On the other hand, older readers not only would recognize the names but would be aware of the personalities attached to them. Throughout his long career in radio and early television, Jack Benny had developed and nurtured the persona of the ultimate tightwad, unwilling to part with even a nickel if he could avoid it. Indeed, in one radio sketch, he is accosted by a gunman, who growls, "Your money or your life!" There is a long silence. The gunman repeats his demand even more threateningly, "Your money or your life," and Benny responds, "I'm thinking . . . I'm thinking!" That, of course, is the primary humor of the eight-pager: Benny is so tight with his money that Mary must sell sex to get him out of hock, and she discovers that she likes it. A secondary strain of humor lies in the fact that Crosby's comedy persona was that of a man with an eye for the ladies who was quite free with his money.

Frank A. Hoffmann, Ph.D.

Most forms of erotica are at least to some extent grounded in humor, but whereas songs, stories, anecdotes, poems, art, and even films usually are impersonal or employ generic characters in generalized situations, the humor of the eight-pagers differs in that it is based primarily on distinct personalities or specific events. Although the sexual antics depicted in them can still be understood and appreciated today, as time passes, the character-specific humor of eight-pagers will become less and less evident to modern readers.

The Capacity for Outrage: Feminism, Humor, and Sex

LEONORE TIEFER, PH.D.

Prologue: Confessions—and a Warning

Three of the things most important to me are sexuality, feminism, and humor. I have written, taught, researched, and lectured for many years about the first two, and the third has been my lifelong companion. I've often felt that I could handle most anything in life except waking up one day no longer funny. Who would I be; how would I stand myself? As a person to whom being funny has always come easily, I have sometimes wondered just exactly what I was doing. Is it about being angry a lot? Being raised to have an outsider's view of things? Speaking before you think? Having too little central nervous system inhibition?

Being invited to write this essay led me to historical, cultural, psychological, and sociological theories of humor, and now I see that humor is every bit as complicated as sexuality. Clearly, it would take another lifetime to really know what I'm doing when I'm being funny. Well, I never did figure out what I'm doing when I have sex, either. Perhaps, on both subjects, remaining ignorant has its benefits—in which case the reader might be well advised to take a look at the cartoons and then go read Harry Potter.

Introduction: Feminist Humor Is Political Humor

Political humor takes many forms but has one clear purpose—social change. Through satire, jokes, cartoons, sarcasm, parody, stand-up comedy, burlesque, camp, wisecracks, gags, puns, lampoons, mockery, ridicule, and wit of every written, verbal, and visual sort, political humor comments critically on social injustice and challenges the fixed social order. Political humor can be lengthy and free-standing, as in a favorite book I shall discuss, Margot Sims's *On the Necessity of Bestializing the Human Female,* or be brief parts of other individual or group political activities such as speeches, op-ed columns and essays (Maureen Dowd in the *New York Times* or Lydia Sargent's monthly column, "Hotel Satire," in *Z* magazine), legislation, court cases, rallies and demonstrations (were you amused by the protest signs about chads at the George Bush presidential inaugural?), petitions, investigative journalism, diaries, folk songs (remember Tom Lehrer?), electronic organizing, speakouts, documentaries, literary analysis, and others.

Feminist humor subverts sexism and patriarchy by legitimizing women's concerns and deflating anti-women positions. "Women belong in the house, and the Senate" has appeared on thousands of bumper stickers and been used in thousands of speeches—and it still makes me smile. "I ain't takin' orders from no one," sang Sophie Tucker in the 1930s, putting into words what many in her audience only thought about. Feminist humor can be soft or loud, obvious or subtle, a lengthy tome or a one-liner, or even just a fleeting facial expression. It qualifies as feminist if it expresses alienation from normative gender and sex roles, and it qualifies as humor if it uses some form of incongruity to make its point. "I'm drowning in the typing pool." "Rock the boat, not the cradle." "A woman who tries to be equal to a man lacks ambition."

Feminist humor serves the larger women's liberation movement as both an attack weapon and a unifier of the group. There's nothing as bonding to movement partisans as sharing the laughter of recognition and outrage with one's comrades, and I've been to many feminist events that used a comedian to get participants' blood moving. "We use our humor as a cure for burnout," wrote Gloria Kaufman in the introduction to one of the most important books on feminist humor, *Pulling Our Own Strings* (Kaufman and Blakely 1980, p. 12). I remember when Representative Pat Schroeder of Colorado delivered some remarks at the Association for Women in Psychology conference in Denver in 1987. "One of the best jobs for a pregnant woman," she said, "would be a position on the Supreme Court. The work is sedentary, and the clothing is loose-fitting." Perfect.

FEMINIST HUMOR VS. WOMEN'S HUMOR

It's important to distinguish feminist (political) humor from humor by or about women that lacks social awareness or social purpose. For example, these two jokes sit next to each other in a "treasury" of humor about women that I found in my neighborhood bookstore:

> 1. "I think, therefore I'm single."
> 2. "Husband: Dearie, don't you think our son gets his brains from me?
> Wife: I suppose so, dear. I still have all of mine." (Myers 1999, p. 155)

The first joke could easily fit in a feminist volume, with its ironic comment on the complexities of women's relation to self and marriage that produces humor by unexpectedly altering a familiar quotation. The second joke seems no more than a traditional wifely put-down, a gotcha wisecrack that is formally funny (it pivots on two meanings for the word "get," a common pun strategy) but lacks social significance. In fact, this type of humor, while formally pro-woman (the woman "wins" the verbal joust) is in fact anti-feminist, in that it reinforces the stereotype of wife as ball-buster. On the other hand, one might argue that, by inappropriately taking credit for their offspring's intelligence, he asked for it, so maybe her refusal to lilt, "Oh, sweetie, your side of the family has all the brains" is a bit of feminist assertion.

Well, who said it was a clear distinction? Continue discussing this among yourselves while I return to the theory of feminist humor.

> The persistent attitude that underlies feminist humor is the attitude of so-
> cial revolution—that is, we are ridiculing a social system that can be, that must be
> changed. . . . The *nonacceptance* of oppression characterizes feminist humor and satire.
> (Gloria Kaufman, introduction to Kaufman and Blakely 1980, p. 13)

As Regina Barreca suggests in *The Penguin Book of Women's Humor,* "Much women's humor, while not *explicitly* political, nevertheless raises questions concerning the accepted wisdom of the system." Her example of this is a joke by actress and comedian Pam Stone:

> I had a girlfriend who told me she was in the hospital for female problems.
> I said, "Get real! What does that mean?" She says, "You know, female problems."
> I said, "What? You can't parallel park? You can't get credit?" (Barreca 1996, p. 1)

Humor theorists would explain that this joke is funny because of the girlfriend's irrational, illogical mistake—the incongruity between the nature of medical problems and parking and credit problems. Added to that incongruity in categories is the further incongruity between the importance of medical and parking or credit problems. Murray Davis (1993) would call this an example of "descending incongruity" because the second topic is clearly of lesser significance than the first. The first joke/incon-

Leonore Tiefer, Ph.D.

gruity—medical problems vs. parallel parking—would have been sufficient, but the comedian goes for a bigger laugh. She pairs the sexist stereotype of women not being able to park with a political observation of women's difficulties obtaining credit, offering a final twist that, I would suggest, does make this joke half-feminist, at least, and definitely funnier. Are you ready to go to Harry Potter yet?

Barreca continues, "When it *is* explicitly political, women's humor often satirizes the social forces designed to keep women in 'their place,' a phrase that has become synonymous with keeping women quietly bound by cultural stereotypes" (pp. 1–2). It seems that for Barreca, for humor to be political, it must take as its subject matter some specific area of oppression, such as public life, employment, the family, or sexuality. But feminists have shown that, dispiriting though this may be to admit, no aspect of life or culture is free from sexism; social forces designed to keep women in "their place" are everywhere, and thus any content will work. As with manslaughter vs. murder, the essential element in deciding whether something is political or not is intention—is the comedian, cartoonist, or satirist trying to stir up some trouble, identifying with a movement or struggle, or just out to get a laugh? Oh, gee, I didn't mean to upset you by mentioning manslaughter.

Why Is Women's Humor Revolutionary?

Naomi Weisstein, a feminist psychologist best known for an influential 1969 critique of sexism in clinical psychology,[1] explained, in her introduction to a book of Ellen Levine's feminist cartoons, why women's use of humor was a revolutionary tactic (Weisstein 1973). Weisstein began by observing that women's capacity for humor had too often been held captive by female socialization. Most women's "livelihood depended on charming some man, having a provider," she wrote, and

> the definition of what was charm depended primarily on our being beautiful, passive, accepting, and mute. . . . we had an obligation to laugh endlessly at men's jokes . . . to be witty and pleasing. But to be able *to mock the requirement that we be all these things* is quite a different thing. . . . laughing at all and only those things which we are expected to laugh at is part of maintaining our charm, and our charm is so bound up with our survival. . . . when people tell us we've lost our sense of humor . . . [i]t means that we may actually be changing our social roles, that we have stopped trying to please. (pp. 6–7, emphasis added)

Weisstein points out that the first step of women's consciousness-raising about humor is to become aware of how women are trained to be appreciative audiences for men's humor (trained, for example, to respond to the husband's taking credit for their offspring's intelligence with a giggle

and smile). The next step is to take a long, serious look at traditional men's humor and recognize how much of it actually targets women, rationalizing their social inferiority and oppression as "natural" and just (of course the kid would get his brains from his father—and his penchant for stalling the car on steep hills, losing his credit cards, and breaking out in hives under stress from his mother).

This consciousness-raising, so painful in the early 1970s, may seem to some like ancient history, so effectively has the women's movement changed social norms. A *Playboy* cartoon drawn by Cliff Roberts that I saved from the 1970s, for example, shows a man at a desk with a framed painting of a screw behind him, saying to a woman job applicant, "The painting behind me represents many things, my dear. It's my product, my philosophy, and what I expect twice a week from my secretary." In the present climate, this cartoon just seems stupid. By de-naturalizing traditional gender rules and sex roles, feminist humor helped bring about these momentous changes.

Weisstein continues,

> One of the paths of coming into consciousness, into politics, for an oppressed group is the realization that their misery is not due to some innate inferiority, to their own flawed characters, but that there is something going on outside that is keeping them down, and that it is *not fair*. . . . [Feminist cartoons] represent the emergence of one type of women's fighting humor; they represent the emergence of part of the effort to build a tradition which defines our oppression, fights it, and *mocks the roles we are forced into and the roles others take in relation to us.* . . . There have been extraordinary obstacles to the development of a woman's fighting humor. We must therefore experiment with the public presentation of such a humor; we must try out forms which throw off the shackles of self-ridicule, self-abnegation; we must tap that capacity for outrage. (Weisstein 1973, pp. 8–9, emphasis added)

With feminist humor, Weisstein concludes,

> we are reclaiming our autonomy and our history. . . . The propitiating laughter, the fixed and charming smiles are over. When we laugh, things are going to be funny. And when we don't laugh, it's because . . . we know what's not funny. (p. 10)

Humor is a form of power, of resistance against oppression, sometimes public, sometimes private. "Making fun of our inferior position raises us above it" (Mindess 1971, p. 48). The effectiveness of this form of resistance is shown by laws in Nazi Germany and Soviet Russia making political humor a direct attack on the government and joke-tellers subject to arrest, deportation, or worse (Lipman 1991). Yet these settings produced a huge underground of spirit-saving, irreverent, savage humor. Although humor has a different role in a democracy or a family than in a totalitarian state, feminists, often living in situations where direct expression of their oppression would be punished, express resistance and hope through humor.

This essay offers a sample of some feminist humor, some of it about sex. I pulled these examples conveniently (or not so conveniently, since I fell off a chair once, but you don't care about that) from my mostly professional, technical, non-funny library. It would be overwhelming to sample all of popular culture for what it can tell us about feminist humor—television sitcoms, newspaper funnies, comedy clubs, film comedies—I'm hyperventilating just at the thought. I did find one reference to just such an encyclopedic overview (Rowe 1995). If someone gets a chance to read it, would you drop me a note and let me know what you learn?

Pictures With (Or, Occasionally, Without) Words

The earliest feminist humor material I have is visual, so let's start with that domain.

EARLY POLITICAL CARTOONS

I bought Alice Sheppard's (1994) history of cartoons in the American suffrage movement because I thought they'd inspire me and make me laugh. Surprisingly, I didn't "get" many of them, because conventions in cartooning have changed and political humor refers to topical events and people who are soon forgotten. Using one's talent in the service of political stands is neither a popular nor a well-paid pursuit. "The role of political cartoonist was judged masculine because it wielded power and served as a privileged vantage point from which to expose and ridicule social structures and political leaders" (Sheppard 1994, p. 25). Sheppard introduces us to numerous unheralded suffrage artists who served their movement. Their cartoons were published in some mainstream outlets, but mostly they drew, unpaid, for movement publications now crumbling in obscure archives.

In the first illustration (figure 1), from 1915, cartoonist Katherine Milhous uses straightforward satire to ridicule the claims of those who argued that voting would make women less feminine, would "unsex" them. This cartoon uses a vocabulary and form of humor still appropriate almost a century later. A second example (figure 2), however, seems quaint, rather than funny. In this 1914

Figure 1. Cartoon by Katherine Milhous, "Votes for women," postcard dated 1915. Reproduced by permission of the Alice Marshall Women's History Collection, Penn State Harrisburg Library, Middletown, Penn.

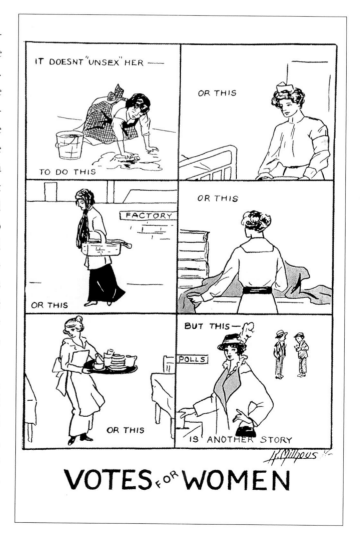

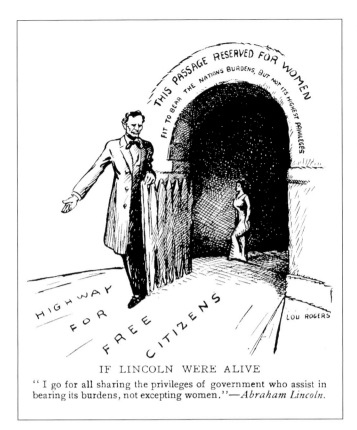

IF LINCOLN WERE ALIVE

" I go for all sharing the privileges of government who assist in bearing its burdens, not excepting women." —*Abraham Lincoln.*

Figure 2. Cartoon by Lou Rogers, "If Lincoln were alive," reprinted from *The Judge,* June 20, 1914, New York, N.Y.

Figure 3. Cartoon by Lou Rogers, "The Latest Addition to the Junk-Heap," reprinted from *Woman's Journal and Suffrage News,* October 18, 1913, Boston, Mass.

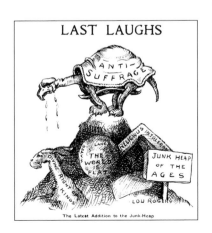

magazine cartoon, Annie ("Lou") Rogers, probably the most prolific and best-known suffrage cartoonist, has Abraham Lincoln welcoming women into full citizenship. This kind of cartoon, more symbolic and inspirational than transgressive in its challenge to the status quo, drew from the repertoire of authority symbols—patriotic, biblical, regal, literary—to advocate for women's rights.

Rogers offered a more humorous image in the next example (figure 3), published in 1913, which ridiculed anti-suffragists as outmoded and ignorant.

Do we relate more to the older cartoons that criticize rather than the ones drawing on inspiring symbols because our sources of inspiration have changed? Or because an inspiring image might work nowadays as an illustration, but a contemporary cartoon needs some sort of punch? Or does our dulled response have to do with the fact that women have had the vote for so long that the subject is too tame to give a twenty-first-century reader any sort of frisson?

EARLY SECOND WAVE POLITICAL CARTOONS

Fast forward to so-called second wave feminism to see more recent cartooning tactics at work. Ellen Levine's 1973 book *"All she needs . . . "* is full of drawings that reveal women's frustration and anger with the status quo. Sexual pleasure and sexual violence, major themes of women's liberation, are favorite subjects, as in the next two examples (figures 4 and 5). The barebones style in which the woman is drawn—naked but unsexy—is itself a feminist statement, and the captions repeat hotly contested 1960s and 1970s arguments about sexual issues. Do these cartoons speak to a contemporary twenty-something woman who has always lived in a culture where the clitoris is known and violence against women is taken seriously? Does she still know what "analysis" is? Would she see these cartoons as quaint the way I see some of the suffrage ones?

Another cartoonist of the early second wave was a woman who signed her cartoons Bülbül. At the beginning of her book, *I'm Not for Women's Lib . . . But,* she explains her philosophy:

I have tried in this cartoon collection to draw what I think and feel about a few aspects of the male culture. Some of the cartoons show the social mechanisms by which women are kept under control and "in their places" by men. Some cartoons show that the deep male prejudice against women covers the entire political spectrum from white male money bags to hip counter-culture. . . . My hope is

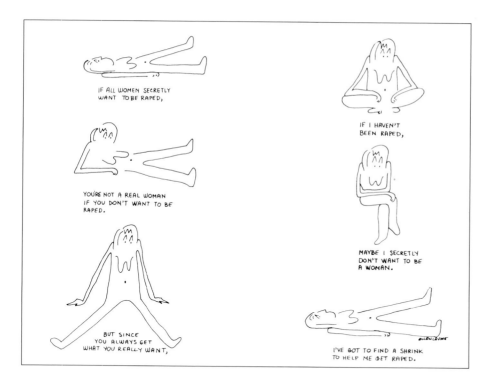

Figure 4. Cartoon by Ellen Levine, reprinted from Levine, "*All she needs . . .*" (New York: Quadrangle/ The New York Times Book Co., 1973).

Figure 5. Cartoon by Ellen Levine, reprinted from Levine, "*All she needs . . .*" (New York: Quadrangle/ The New York Times Book Co., 1973).

that these cartoons in their small way will help women, with a chuckle, in their struggle for dignity and self-determination. (n.p.)

So earnest, so uncomplicated! In Bülbül's world, women usually have little power or voice. Two tiny men fight on top of a huge woman's body, and one says, "Get off! This is MY territory." A bearded guitar player strums an instrument made of a woman's body, singing "Love me baby! Me! Me! Me!" In successive panels, a woman says to a man, "I feel thoroughly put down," "It's a constant struggle for simple dignity," "For personhood," and in the final panel, the man replies, "You need a good lay, chick." But, in one cartoon, a woman goes into the office of "Doctor Tut-Tut Shrink." He first says, "You are suffering from your inability to handle your proper female role" and then, "My dear, you are suffering from the delusions of an over-emotional female." Finally, she sits up on the couch and says, "Doctor, what I'm suffering from is reality" and, leaping off the couch in the final panel, she shouts, "AND YOU!"

Bülbül's captions, especially when presented

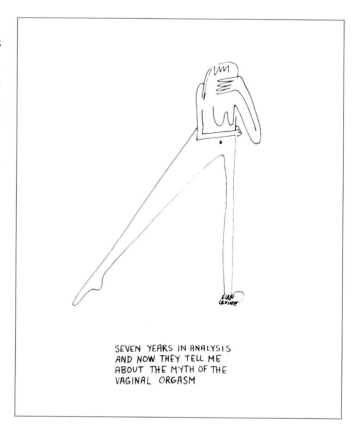

SEVEN YEARS IN ANALYSIS AND NOW THEY TELL ME ABOUT THE MYTH OF THE VAGINAL ORGASM

without the drawings, seem so overstated as to provoke a backlash of embarrassment. "Oh, come on. Men and psychiatrists don't really talk like that, give 'em a break." It's a variant of "Where's your sense of humor, honey, getting angry over every little thing?!" But exaggeration is a hallmark of certain kinds of American humor (think of Paul Bunyan). "The easiest way to make things laughable is to exaggerate to the point of absurdity their salient traits" (Max Eastman quoted in Davis 1993, p. 86). If, in other settings, this kind of humor is not only okay but practically patriotic, complaints against it when used by feminists are a form of backlash. They reveal how uncomfortable we are with overt hostility, and how precariously feminist humor must be balanced to work. Sigh. I always get depressed by backlash; you'll have to excuse me. Sisyphus was just not my favorite Greek.

GRRRLZ COMICS: ARE WE GETTING MORE THAN WE BARGAINED FOR?

Fast-forward to the current world of comics, which, like the larger world of popular culture, is complicated, segmented, and a little overwhelming. A recent lavishly illustrated text provides an overview history of comics about girls and women, which, not coincidentally, have only recently been drawn by girls and women themselves (Robbins 1999). Comics, which are often short strips but sometimes novels told through pictures, are always funny, because of their incongruity or transgression. However, at the point in the 1970s when feminist cartoonists like Bülbül and Ellen Levine emerged, a genre of "womyn's" or "wimmen's comix" emerged in the new underground comics scene with names like *It Ain't Me, Babe; Tits 'n' Clits; Wet Satin;* and *Pudge, Girl Blimp.* Sometimes labeled pornography, these cartoon novels, occasionally funny, always provocative, took on issues important to women's lives—menstruation, contraception, lesbianism, abortion, sex, family life, nuclear war, tampons. These books continue to the present, but, as with feminist culture in general, the number of womandrawn, woman-oriented comics is minuscule within the overall genre.

THE BEST FEMINIST SEX CARTOON IN THE WORLD

I have gotten huge laughs of recognition and appreciation in the past couple of years when I have shown the Viagra (or is it anti-Viagra?) cartoon (figure 6) as part of my lectures on the current medicalization of sexuality. The idea of Viagra "supplements," in the first instance, directly attacks the idea that Viagra, with its limited peripheral hemodynamic effects, is sufficient to make a man into an adequate lover. Many women are apoplectic over the utopian messages in Viagra marketing that imply that the little blue pill's likely side effects are romance, love, and tender passion, rather

Leonore Tiefer, Ph.D.

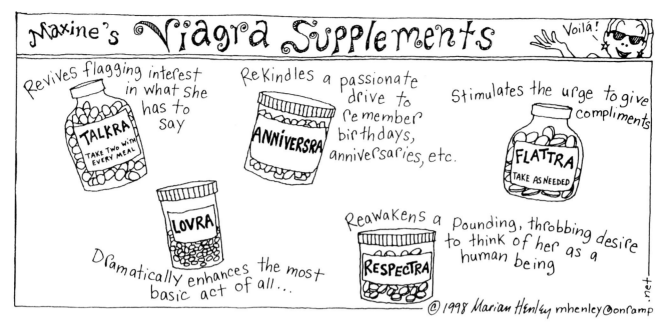

Figure 6. Cartoon by Marian Henley, "Maxine's Viagra Supplements," published in *Ms.*, October/November 1999. Maxine!Comix © Marian Henley. Reprinted by permission of the artist.

than the nausea and headaches pointed out in the insert literature's small print. Moreover, cartoonist Marian Henley has pinpointed five of the areas feminist sex researchers like Shere Hite (1976, 1987) repeatedly emphasize are central to many women's sexual satisfaction, areas of no measurable interest to most sex researchers, sex therapy theorists, or, certainly, pharmaceutical companies. The humor of this cartoon raises consciousness about what many women want and how we continue to wait in vain.

Words With (Or, Occasionally, Without) Pictures

How has feminist humor told its story in words? There are one-liner jokes, of course. They are the icing on the cake. But real, doughy, feminist humor requires an extended opportunity to lay out an argument. It's hard, after all, to stuff into a one-liner a statement of a social problem, a few illustrations to show it's not just a little bitty problem, a dozen more illustrations to show we are really talking global, a hundred more examples to show this problem has been with us since people lived in caves, and then some feminist solutions to top it off. Here are a few favorite examples.

THE BLOODY BODY

Gloria Steinem's 1978 essay in *Ms.* magazine, "If Men Could Menstruate" (reprinted in Kaufman and Blakely 1980) is a skyscraper in the landmarks of feminist humor (have I got your attention, Mrs. Bunyan?). Incorporating exaggeration, punning, parody, and an escalating string of zingers, this satirical essay is a premiere example of how feminist humor can take

a subject of central importance to women's everyday lives and show how contemporary culture, dominated by topics important to men, trivializes, ignores, and derides it. I'll give you only a brief taste of this amazing satire:[2]

> What would happen, for instance, if suddenly, magically, men could menstruate and women could not? Men would brag about how long and how much. Boys would mark the onset of menses, that longed-for proof of manhood, with religious ritual. . . . Congress would fund a National Institute of Dysmenorrhea. . . . Sanitary supplies would be federally funded and free [although] some men would still pay for prestige brands. . . . Military men . . . would cite menstruation . . . as proof that only men could serve in the Army ("you have to give blood to take blood"). . . . Men would convince women that intercourse was *more* pleasurable at "that time of the month." (Steinem 1980, pp. 25–26)

Why is this so funny? First of all, it is about how menstruation, a topic not easily discussed in public and often regarded with paralyzing embarrassment, shame, and disgust by women in many cultures, could overnight become a topic of extreme pride if cultural rules were changed. Wow! In a brilliant trick of reversal, Steinem shows that there is nothing *intrinsically* bad about menstruation; it's all because of sexism and patriarchy. The relief from embarrassment and shame that women experience on hearing this satire (as with the currently popular *Vagina Monologues* by playwright Eve Ensler) is a measure of the subject's offensiveness and contemptuousness, exactly the feminist point. Moreover (as if this weren't enough!), Steinem's satire specifically pinpoints so many of the ways that women are generally oppressed (e.g., ignored in scientific research, excluded from the military, offered no rituals for life-stage transitions) that the feminist reader experiences moments of relief, release, and sheer triumphant pleasure one after another. Perfect.

MARGOT SIMS AND THE TRADITION OF ANTI-FEMINIST SOCIOBIOLOGY

Feminism is about destroying ideologies and practices of female subordination. One of the most enduring anti-feminist ideologies says female inferiority is dictated by nature, biology, hormones, genes—by whatever is most unchangeable according to current scientific thinking. No wonder some of the most pointed feminist satires take on the so-called evolutionary origins of gender inequality.

Margot Sims (1982), claiming to be the founder of the Center for the Study of Human Types (on the site of a former seminary of the Order of the Most Precious Bleeding Heart in central Nebraska), argues that, no matter what measure you use, men and women cannot possibly be members of the same species. Whether the measure is anatomy, reproductive physiology, puberty, fertility, sexual response, sexual conditionability, courtship pat-

Leonore Tiefer, Ph.D.

terns, or masturbatory habits, Sims argues in 140 liberally illustrated pages that male humans are closer to primates and other animals than are women; i.e., women are a more evolved species. The only route to human harmony, she concludes, is neither segregation of the two sexes nor humanization of the male gender, but "female bestialization." I'll get to that in a moment.

Her writing, like Steinem's and most feminist satirists', allows her to comment indirectly on many feminist issues while making her own argument. I'll quote first from the chapter on courtship:

> Members of the same species are innately interested in identifying and cooperating with other members of their species for the purpose of mating. . . . Since beast humans [men] and true humans [women] are not very closely related species, it is no surprise that they employ courtship behaviors which are anti-complementary. This is an obvious clue that human beings could not possibly all be one species. The male beast human . . . favors the quick and overt; the [female true human favors] the slow and subtle. . . . True humans cope with this anti-complementarity in several ways. . . . Without the ability to fantasize, women would certainly be more insane than they normally are. With their fantasy of "let's pretend men are true human beings," many can go for long periods of time. (Sims 1982, pp. 77–78)

Or consider this, from the chapter on sex physiology:

> The relative complexity of a species' sex response appears to be correlated with evolutionary ranking. Sex research pioneers Masters and Johnson found the true human's sex response cycle to be extremely varied and complex, the beast human's predictable and simple. . . . the beast human travels the same, well-worn unswerving path every time he ascends Mt. Orgasm . . . the true human, by contrast, rarely travels the same path twice. (p. 37)

Sims goes on to attribute these differences to more elaborate brain development in the "true" human, and notes the superiority of cognitive processes like thought and emotion over reflex functions. When in her conclusion, then, Sims gets to the necessity of "bestializing" women to make them more equal to men, she focuses on the surgery that women will need:

> The problem, of course, lies in determining exactly where in the female anatomy the emotional nugget is located so surgeons can pluck it out. I predict that someday bestialization of newborn girls will be as routine as circumcision of newborn boys is today. But [we will have to wait] until science has answered the questions: "Where is the higher nature of the true human housed?" and "How can it be excised?" (pp. 130–131)

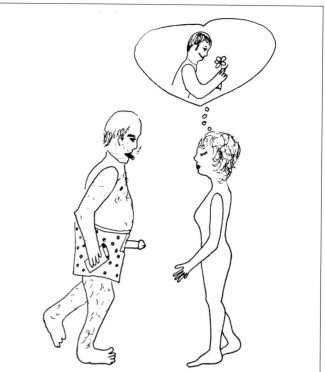

Figure 5.3 Fantasies enable many true human females to cope more satisfactorily with their lives.

Figure 7. Cartoon by Margot Sims, "Fantasies Enable Many True Human Females to Cope More Satisfactorily with Their Lives," reprinted from Sims, *On the Necessity of Bestializing the Human Female* (Boston: South End Press, 1982).

Margot Sims lampoons the endless scientific passion to pinpoint the physiology of complex sex differences and sociobiological efforts to reduce all human behaviors to evolutionary and biological origins, efforts which all too often make women out to be whiny, diminished versions of the ideal—that is, male—human being. Her book is a refreshing lozenge for the feminist scientist with decades of laryngitis from preaching against pseudoscientific misogyny.

SO MANY WAYS TO BE CRAZY, SO LITTLE TIME

Extensive feminist research has shown how social oppression of women has been disguised and reframed as individual women's pathologies. Instead of protesting the lack of child care and good education, women hear that their children are at risk because they are neglectful and incompetent mothers. Instead of attacking the images disseminated by oppressive fashion and film industries, women come to believe they are fat and ugly. Instead of recognizing how sexual harassment, low pay, poor benefits, and other working conditions are stressful and exploitative, overworked women learn to label themselves as having depression and other psychological problems.

There have been many satirical contributions to this genre. *Our Syndromes, Ourselves* (Hamilton 2000) is an outstanding recent effort to ridicule the endless production of new sicknesses with which to label women. By calling "bad perms," "blind dates from hell," and "road trips with the kids" causes of "post-traumatic stress disorder," for example, Hamilton marries an Erma Bombeck–like attention to the minutiae of women's everyday life to the feminist *Our Bodies, Ourselves* tradition of naming our own problems rather than letting the medical establishment have the power.

Feminist psychologists have written about how the multiplication of psychiatrically defined mental disorders like "premenstrual syndrome" and "self-defeating personality disorder" does much harm to women in the guise of medical interest and concern (Caplan 1995). One of my favorite examples of feminist humor on this theme is the slim satire *Are Children Neglecting Their Mothers?* by the pseudonymous "famous psychoanalyst" Hadley V. Baxendale, M.D., Ph.D. (1974). In chapter 3, Dr. B. explains that if children do not pay enough attention to their moms, if they play too often with their friends or go to summer camp too enthusiastically, there will be trouble down the road.

> If a child never makes his mother feel that she is the focal figure in his life, if he insists on leaving her every day in pursuit of selfish interests of his own, . . . the mother may go through an unusually trying climacteric, have a nervous breakdown, or grow addicted to prescription drugs. (Baxendale 1974, p. 30)

This book begins with a disclaimer: "A warning to the literal minded reader. All interviews in this book are, of course, fictitious" (p. 11). Unfor-

Leonore Tiefer, Ph.D.

tunately, when *Psychology Today* magazine offered some of Dr. B's advice in a short 1975 piece titled "Why a Person Who Menstruates Is Unfit to Be a Mother," it neglected to indicate that this was satire, and the magazine was flooded with complaints (Tavris 1992, p. 131).

The failure of some *Psychology Today* readers to recognize Baxendale as a feminist humorist is noteworthy. Humor inverts reality, offers something incongruous. If the humor is not recognized, then reality has not been inverted. Some feminist readers were appalled that Dr. Baxendale would call for mothers to mistreat their children for their own selfish purposes. They felt Dr. Baxendale was anti-woman! It's as if a feminist humorist called for women to walk naked back and forth past construction sites so workers could get a proper eyeful without endangering themselves, and readers complained, saying that such women might catch cold. Lack of humor about certain topics is a sign of how important they are, but excessive political correctness (nothing bad about women can ever be said or drawn) can also be oppressive.

Feminist Humor about Sex

Are you ready for the quiz? What would feminist humor about sex focus on most? (a) men's genital organs, those that work and those that don't; (b) hot lusty women wanting lots of sex in lots of ways; (c) lesbian meeting and mating habits; (d) men's ideas of pleasure and romance; (e) what women think about during sexual activities; (f) rape, incest, and sexual harassment? If you answered, "all of the above," you have got the point of this chapter. It's not one subject, it's one spin. The feminist wit will spin genital physiology, lust, men's foibles, and anything else even remotely connected in order to raise women's consciousness and resist sexism.

And what form will the feminist humor take? Any and every form. Mae West camped her answer. Sophie Tucker sang, "You gotta see Mama every night or you can't see Mama at all." Cynthia Heimel's sarcastic magazine essays, published in half a dozen collections, have drop-dead titles like *If You Can't Live without Me, Why Aren't You Dead Yet?* (Heimel 1991). There's stand-up comedian Kate Clinton and cartoonist Nicole Hollander. Feminist cartoonists and comedians have even taken on sexual abuse by ridiculing the ways police and psychiatrists trivialize these subjects.

In a famous 1948 parody, Ruth Herschberger interviewed Josie, a chimpanzee in the lab of primatologist Robert M. Yerkes, about the conclusions the scientist drew about her sexual behavior. Yerkes seemed unable to see Josie's sexuality as anything but subordinate to that of her mate, Jack. Josie complained, "Receptive? I'm about as receptive as a lion waiting to be fed."

Jack and I can go through almost the same motions, but by the time it gets down on paper, it has one name when Jack does it, and another if it was me. For instance, when Jack was at the food chute and I gestured in sexual invitation to him, . . . this was put down as "favor-currying" on my part. . . . The reason people are so sure that I traded sexual accommodation for food . . . is because nobody thinks women enjoy . . . sex. Maybe human females don't enjoy sex, but we chimps resent any forced analogy with humans. (Herschberger 1948, pp. 10–12)

Feminist Humor and the "War" between the Sexes

If feminist humor is a weapon, are men the target? Is feminist humor just a form of man-hating? In her recent analysis of gender relations and gender ideologies, *My Enemy, My Love: Man-Hating and Ambivalence in Women's Lives,* journalist Judith Levine argues that "Man-hating is a collective, cultural problem. . . . Man-hating isn't a function of feminism; it's a function of the *reasons* for feminism" (Levine 1992, p. 4). She sees man-hating as an inevitable result of the feminist insight, "The personal is political,"

which means figuring out how the big hand of Oppression feels when it comes sharply into contact with one's own person. To recognize oppression is to be infuriated, and to recognize it right here at home is to be infuriated at *someone,* someone you know [a brother, boyfriend, co-worker, husband, or father, for example]— sometimes, in fact, to hate him. (p. 4)

In our fast-changing society, Levine argues, relations between men and women are uncertain, awkward, improvisational, and, frequently, full of tension. The changes, of course, are more often celebrated and promoted by feminist women than by the men in their lives, producing the myriad forms of hostility (the "taxonomy of man-hating") Levine documents in her interviews and examination of popular culture. Man-hating is disguised in most women's lives, for reasons that include fear, women's continuing emotional and financial dependency, and women's own often unacknowledged ambivalence about contemporary sex-role and sexual changes. And humor plays a big part in this overall picture.

Remember when Gloria Steinem tried to draw a clear line between good dirty pictures—erotica—and bad dirty pictures—pornography? Trying to do that with humor about gender is equally ill-fated. There is no clear line between good "feminist" humor—constructive, political, reformist—and bad "non-feminist" humor—hostile, women-are-good men-are-bad, simpleminded—although we can make some meaningful distinctions, as I indicated in my introduction. The struggle against misogyny (woman-hating), sexism, and patriarchy is a huge revolution, and every one of us is involved, like it or not. During the interview tour after her book was published, Levine found that the word "man-hating" in the subtitle was so inflammatory that many people couldn't get past it to read the book. So, in

Leonore Tiefer, Ph.D.

the paperback version, she changed it to *Women, Men, and the Dilemmas of Gender*. But she left all the jokes in, like this description of sex—pure revenge, most probably not good feminist humor—by the British comic Jenny Lecoat:

> He, laboring away, pauses to ask, "Are you nearly there?" "It's hard to say," says she. He plunges on. "If you imagine it as a journey from here to China, where would you be?" She considers. "The kitchen." (Levine 1992, p. 59)

Epilogue

Writing this essay reminded me of many painful things about women's lives and struggles for change. I couldn't stand dealing with it all in silence, so I looked for some music to keep me company. Over and over I played the original cast recording of the 1997 Broadway musical *Titanic* (not to be confused with the movie of the same name) on the CD player next to my desk. And each time I heard the overture, the finale, and some of the passionate songs about aspirations and innocence destroyed, I cried. Builder, owner, captain, crew, rich first-class passengers, poor third-class passengers—all sing to an engineering miracle that will bring their hearts' desire—and bang, they're dead. I'm writing about feminist resistance and triumph through satire and cartoons, and I'm weeping, sniffling, and wiping my eyes over a tragedy brought about by pride, greed, and bad luck. Feminist political humor exists at the edge of tragic hopelessness, and you need to feel that edge to get it.

NOTES

1. "'Kinder, Küche, Kirche' as Scientific Law: Psychology Constructs the Female." Reprinted in *Sisterhood is Powerful,* the revolutionary anthology edited by Robin Morgan (New York: Random House, 1970).

2. So you should rush right out and buy the reissued volume of *Pulling Our Own Strings* (Bloomington: Indiana University Press, 1994) so you can read it all.

REFERENCES

Barreca, Regina, ed. 1996. *The Penguin Book of Women's Humor.* New York: Penguin.
Baxendale, Hadley V. 1974. *Are Children Neglecting Their Mothers?* Garden City, N.Y.: Doubleday.
Bülbül. 1973. *I'm Not for Women's Lib . . . But.* Stanford, Calif.: New Seed.
Caplan, Paula J. 1995. *They Say You're Crazy: How the World's Most Powerful Psychiatrists Decide Who's Normal.* Reading, Mass.: Addison-Wesley.
Davis, Murray S. 1993. *What's So Funny? The Comic Conception of Culture and Society.* Chicago: University of Chicago Press.
Hamilton, Cathy. 2000. *Our Syndromes, Ourselves.* Kansas City: Andrews McMeel.

Heimel, Cynthia. 1991. *If You Can't Live without Me, Why Aren't You Dead Yet?* New York: HarperCollins.

Herschberger, Ruth. 1948. *Adam's Rib.* New York: Harper and Row.

Hite, Shere. 1976. *The Hite Report: A Nationwide Study on Female Sexuality.* New York: Macmillan.

———. 1987. *The Hite Report: Women and Love: A Cultural Revolution in Progress.* New York: Knopf.

Kaufman, Gloria, and Mary Kay Blakely, eds. 1980. *Pulling Our Own Strings: Feminist Humor and Satire.* With an introduction by Gloria Kaufman. Bloomington: Indiana University Press.

Levine, Ellen. 1973. *"All she needs . . . ".* New York: Quadrangle/The New York Times Book Co.

Levine, Judith. 1992. *My Enemy, My Love: Man-Hating and Ambivalence in Women's Lives.* New York: Doubleday.

Lipman, Steve. 1991. *Laughter in Hell: The Use of Humor during the Holocaust.* Northvale, N.J.: Jason Aronson.

Mindess, Harvey. 1971. *Laughter and Liberation.* Los Angeles: Nash.

Myers, James E. 1999. *A Treasury of Victorious Women's Humor.* Springfield, Ill.: Lincoln-Herndon.

Robbins, Trina. 1999. *Girls to Grrrlz: A History of Comics from Teens to Zines.* San Francisco: Chronicle.

Rowe, Kathleen. 1995. *The Unruly Woman: Gender and the Genres of Laughter.* Austin: University of Texas Press.

Sheppard, Alice. 1994. *Cartooning for Suffrage.* Albuquerque: University of New Mexico Press.

Sims, Margot. 1982. *On the Necessity of Bestializing the Human Female.* Boston: South End Press.

Steinem, Gloria. 1980. "If Men Could Menstruate: A Political Fantasy." In *Pulling Our Own Strings: Feminist Humor and Satire,* ed. Gloria Kaufman and Mary Kay Blakely, pp. 25–26. Bloomington: Indiana University Press.

Tavris, Carol. 1992. *The Mismeasure of Woman.* New York: Simon and Schuster.

Walby, Sylvia. 1993. "'Backlash' in Historical Context." In *Making Connections: Women's Studies, Women's Movements, Women's Lives,* ed. Mary Kennedy, Cathy Lubelska, and Val Walsh, pp. 79–89. London: Taylor and Francis.

Weisstein, Naomi. 1973. Introduction to *"All she needs . . . ",* by Ellen Levine. New York: Quadrangle/The New York Times Book Co.

For Better Sex, Says Dr. Frieda, See "Robert's Rules of Order"

CAROL TAVRIS AND LEONORE TIEFER

In the course of their research on human sexuality the authors obtained an exclusive interview with Dr. Frieda Tingle, who, they claim, is the world's leading expert on sex. The following conversation is excerpted from that interview.

Q. Dr. Tingle, what do you think of "Sex in America"?
A. I think it would be a good idea.

Q. Do you think Americans are too concerned about orgasms?
A. Whose? Their own or their neighbors'?
Q. We mean in general.
A. Orgasm is very important for many Americans because it tells them when the sexual encounter is over. Most of these people enjoy competitive sports, where some official is forever blowing a whistle or waving a little flag to let them know the event has ended. Without orgasm, they would be fumbling around, never knowing when it was time to suggest a game of Scrabble or a corned-beef sandwich.

Q. Dr. Tingle, if you are the world's most renowned sex expert, how come no one has heard of you?
A. It's my own fault. A talk show host asked me a perfectly normal question—something like, "What is your preferred sexual position, Dr.

Tingle?" or "Please give us a description of your partner's pleasure probe"—when something came over me. I said, without thinking, "It's none of your business." So now no one in the news media is talking to me.

Q. Dr. Tingle, since issues of sexual orientation are so much in the news these days, will you tell us your own sexual preference?

A. Certainly. Strawberry.

Q. Tell us some of the most important findings from your work.

A. We now know that a man's most important sex organ is his fingers, and a woman's most important sex organ is her mouth. With his fingers, he feeds her chocolate éclairs. With her mouth, she tells him how wonderful he is.

Q. With all we keep hearing about the precise latitude and longitude of the female orgasm, where, exactly, does it occur?

A. According to our psychoemotophysioneurohormonological studies, orgasm occurs in the head, heart, toes, nose, genitals, shoulders, stomach and Louise's apartment.

Q. Louise's apartment?

A. She's my next-door neighbor. Believe me, a lot of orgasms go on there.

Q. What kinds of things affect a person's ability to have an orgasm?

A. One important factor is diet. Many times I have been told that it is impossible to have an orgasm after eating an entire pizza. I assume this has something to do with the Italian religious taboo against sexual abandon. Another factor is the weather. Many patients have told me that if the window is open and they are being rained on, it is particularly difficult to have the orgasmic experience. Obviously, since rain signifies the waters of the womb, thoughts of the birth experience are interfering with their sexual concentration.

Q. Anything else?

A. There is no correlation between orgasm and age, love, lust, body shape, mental shape, income, education, location or occupation. So far, the rain and the pizza are the only things I have found that play a consistent role.

Q. Is it rude to ask whether your partner has had an orgasm, or is it rude not to ask?

A. I'm always glad to answer a question on etiquette, because it shows that my interviewer has been well brought up. In my new book, *Doing It with Decorum*, I devote a whole chapter to orgasmic obligations. My opinion is that asking, "Darling, did you have the ultimate orgasmic experi-

ence?" is too little, too late. The correct question to ask is, "Would you like to have the ultimate orgasmic experience?" before beginning.

Q. What, then, is a proper standard of sexual etiquette in this modern age?

A. Too many people keep trying to apply the golden rule, which works wonderfully everywhere else but in bed. Do not treat your partner as you would have your partner do unto you. This makes partners confused and irritable. She wants her back rubbed and he wants his ears nuzzled, so she rubs his back and he nuzzles her ears. The moral is to do unto your partners as they would be done by. I'm not anti-biblical, though. It's very nice to turn the other cheek.

Q. If the Bible is not the appropriate guide, what is?

A. "Robert's Rules of Order." You could look them up, and you'll see they suit perfectly: "One proposal at a time," "the right of free and full debate," "second the motion," "the principle of equality" and "courtesy."

Q. Do men and women have different orgasms, Doctor?

A. Well, when you ask men and women to write down what orgasm feels like, you can't tell which description was written by whom. This means either that orgasm is the same for both sexes or that nobody can write clearly anymore.

Q. Dr. Tingle, in your many years as an expert on sexuality, what is the most common question you have been asked?

A. That one.

Q. Well then, what is the most unusual question?

A. A woman once asked me how she could tell the difference between multiple orgasms and hiccups.

Q. What did you tell her?

A. I told her it was six of one, half a dozen of the other.

Gershon Legman: Lord of the Lewd

MIKITA BROTTMAN, PH.D.

Gershon Legman, 1973. Photograph by John F. Waggaman. Reproduced by permission of the photographer.

No discussion of the relationship between sex and humor would be complete without reference to the eccentric scholar and sexologist Gershon Legman, that defiant and irascible genius perhaps best known as the Diderot of the dirty joke. Legman, who died in February 1999, was estranged from the established world of academic sexologists and folklorists, and from the cultural establishment in general, mainly because his inability to pander or compromise upset and alarmed many more traditional scholars. Legman's writing is invariably full of angry remarks, virulent asides, value judgments, and irrational prejudices, and those people used to dealing with the common platitudes of scholarly writing often have a hard time accommodating themselves to the belligerent personality that pervades his brisk, testy style. To those who feel uncomfortable with compromise, however, Legman's writing is endlessly compelling, and reflects a particularly rare form of enlightened precocity.

1.

In the early 1940s, Alfred Kinsey, then working on the first volume of what became known as the first "Kinsey Report," was looking for someone with a knowledge of arcane erotica to serve as his New York book buyer. He was hoping to find the kind of person who'd be adept at ploughing

through the dusty annals of sexual curiosities in the homes of booksellers and private collectors, someone who could help him locate such rare items as the twelve-volume Machen translation of the memoirs of Casanova, the English translation of Bloch's *Beiträge zur Aetiologie der Psychopathia Sexualis,* and the sixteen original volumes of Richard Burton's *Arabian Knights* with all their footnotes on Levantine sexuality. Eventually he was given the name of Gershon Legman, a lay sexologist and amateur lexicographer who was at the time working for Robert Latou Dickinson's maternal health program in New York.

Legman, a young man in his early twenties with no formal education, was thrilled by the opportunity to take on a job that was perfectly suited to his own eclectic interests in erotic anatomy. Unfortunately, however, the job didn't last long. Obstinate and contentious by nature, Legman always found it hard to work for anyone but himself, and by late 1943 he was exchanging angry letters with Kinsey, at first in relation to a statistical debate about penis measurements and then, consistently, about money. By 1944 Kinsey had found other, less contentious book buyers, and cut off his official relationship with the troublesome Legman. However, despite his difficult relationship with Kinsey, Legman remained proud for the rest of his life of his early association with what was to become The Kinsey Institute, and as late as 1976 still referred to himself as Kinsey's "first official bibliographer."

Throughout the forties and early fifties, Legman was seriously harassed by the post office for sending and receiving "offensive" material through the mail. At some time during 1952 his mail stopped being delivered, which confirmed his decision to leave the United States for good. A small inheritance from an uncle allowed Gershon and his first wife, Beverly Keith, to move to Europe; they arrived on the French Riviera by train and were overwhelmed by the wonderful sight of the bougainvillea. The Legmans decided to settle in Valbonne, a small town just outside Antibes in the Alpes Maritimes, where Legman purchased a ruined installation of the Knights Templar, with an eye to restoration. In this small building he installed his enormous library and collection of arcane erotica, planning to pursue his research at the Bibliotheque Nationale in Paris and perhaps the British Museum in London.

2.

In 1968, Legman published the first volume of what was to become his magnum opus, *Rationale of the Dirty Joke: An Analysis of Sexual Humor*—a work he'd been preparing for more than thirty years. Grove Press in New York published the American edition, and a British edition was published

by Jonathan Cape in London in 1969. This enormous volume of 811 pages contains over two thousand jokes, and has since been reprinted twice in paperback and translated into German, French, and Italian. Legman claims that the book was partly inspired by Victor Hugo's masterpiece *The Man Who Laughs;* for his epigraph, he takes a line from Beaumarchais' *Figaro:* "I laugh, so I may not cry."

As this telling inscription suggests, *Rationale* is a very unfunny book, and certainly not intended as a compendium of dirty jokes to be brought out at stag parties or kept handy by the toilet. In part, the book serves to illustrate that such jokes are rarely "new" and seldom "invented," but are variants of jokes from other times and civilizations, many being traceable to the Renaissance or earlier, appearing in the works of Boccaccio, Apuleius, and other tale-tellers. All such jokes, writes Legman, "arrive to us from other countries and older civilizations, by way of oral and printed infiltrations over a period of centuries, and along certain massive and well-delimited cultural highways" (*Rationale* 34). He mindfully emphasizes the connections between dirty jokes and folklore, deducing from the timeless popularity of such jokes and their geographical ubiquity that they are important attempts to allay or express fear of and anxieties about sex and to project these fears and anxieties onto others. He argues that dirty jokes spring from unconscious fears and rages that are practically universal, although they tend to manifest themselves more often in males than females.

"[I]t may be stated axiomatically," writes Legman in the book's introduction, "that a person's favorite joke is a key to that person's character, a rule of thumb all the more invariable in the case of highly neurotic persons. In other words, the only joke you know how to tell is *you*" (16). He goes on to make the case that all jokes are aggressive in nature, and dirty jokes in particular—generally told by males about females—are a vehicle by which men permit themselves to express their hostility toward women. Such jokes, claims Legman, deal with a highly charged neurotic situation in which the originator or the teller of the joke has been forced to live; indeed, the function of humor in general is to reconcile us to the painful, unacceptable, or tragic aspects of the human condition. Consequently, the telling of the dirty joke permits a "moral vacation" (743) of uncontrolled hostility; the laughter aroused by such jokes, if any, is less often of amusement than of relief, "when the ordeal of listening is over" (38).

The jokes in *Rationale* are arranged according to category and discussed in relation to the psychological motives behind their telling. One important category, for example, is the sadistic joke, in which the listener is made into a victim by being duped into expecting a point or denouement that doesn't exist, as in the shaggy-dog story. Another category is the masochistic joke, in which the butt or victim is the joker himself. Legman

points out that many Jewish jokes are of this kind, and he makes the interesting point that the material on which Freud based his *Jokes and Their Relation to the Unconscious* is full of these kinds of jokes. Jokes about men who are irrationally fastidious about their sexual tastes, or men who can't find what they're looking for in a thousand women, are interpreted as revealing homosexual inclinations. Jokes about sexual organs that are either too large or too small in relation to their opposite number, and which make coupling impossible, are analyzed as expressing fears about temperamental incompatibility, comically amplifying the suppressed or merely tacit mismatched qualities and dispositions of "normal" couples. Castration jokes, like *vagina dentata* stories, are told to reassure both teller and listener that these horrible things, though they may happen, happen only to somebody else.

Legman's intellectual grounding is in Freudian psychoanalysis viewed through a strong sense of sexual and social idealism. His theoretical ideas clearly belong to the Freudian orthodoxy as laid down in *Jokes and Their Relation to the Unconscious.* However, like all of Legman's work, *Rationale* boils over with learned allusions, gynecological admonitions, psychoanalytic evaluations, value judgments, and irrational attacks. His prose, as always, is full of liberating verve, color, and exhaustively documented diatribes, relieved from time to time by slanderous attacks on famous people and an obsession with scarcely relevant minutiae. Although it was slammed by reviewers, the book was widely sought after, developing something of a legendary underground reputation. As a result, Legman became well known and widely respected—not in university circles, but in that *demi-monde* on the fringes of academia that's haunted by ghostwriters, booksellers, and those collectors of the obscure and arcane amongst whom Legman had always been most comfortable.

3.

The second volume of *Rationale of the Dirty Joke,* titled *No Laughing Matter,* was first published in the United States in 1975. This volume contains the dirtiest jokes of all—what Legman sometimes refers to as the "nasty-nasties." Categories include Prostitution, Disease and Disgust, Castration, Dysphemism and Insults, and Scatology; subcategories include Defecation, Feces as Gift, Anal Sadism, and Semen as Food. "This book," boasts its author, "is full of material so disgusting that it will make any decent, clean, healthy person want to throw up" (*No Laughing Matter* 14).

In the introduction to *No Laughing Matter,* Legman repeats his argument that the same dirty jokes are told everywhere, and have been told throughout history, though in mutated forms that reflect the particular

characteristics of the countries they pass through. He also repeats his belief that dirty jokes create an arsenal or form of defense against attackers; "under the mask of humor," he writes, "all men are enemies" (10). In this context, Legman refers to an important passage in Freud on the compulsive and often hysterical telling of anti-Jewish jokes—the tellers themselves being Jewish—during the dangerous antisemitic period of the Dreyfus trial just preceding the First World War in Europe. This is a classic example of the joke as a form of confessional—a desperate begging by the teller for forgiveness or shriving. Legman explains this complex with characteristic eloquence:

> The cycle of telling and listening, listening and telling must be endlessly and compulsively repeated for a lifetime, the teller visibly taking the least pleasure of all in the humor at which he struggles so hard, and in which, at the end, he stands like the hungry child he is, darkly famished at their feasting while the audience laughs. (47)

In another interesting passage, he refers again to his theory that a person's sexual neuroses can be determined through a close analysis of their favorite dirty joke, which carries a powerful clue to the teller's own psychological bent, something that they're struggling to unveil without revealing it. "Your favorite joke is your psychological signature" (16), writes Legman. And everybody has a favorite. "If we are not to be left floating in a hopeless relativism, and without the possibility of making any distinctions or judgements at all," he points out, "it's precisely in these favorites of every joke-teller's, in his or her special repertory, that we may discern the face hidden behind the mask" (14). On this theme, he adds that his own name is a dirty joke—and an inverted one, since he happens to be a "tit-man" rather than a "leg-man."

In *No Laughing Matter*, Legman also has some rather incisive comments to make about those who feel compelled to tell jokes on a regular basis, especially when such characters have a "need to 'do their thing' aggressively and publicly" and have "found a protective cover for their neurosis" in forms like popular entertainment and stand-up comedy (39). In order to understand the relationship between comedian and audience, Legman, like Freud, focuses powerfully on the joke-teller's intentions and on the specific (if unconscious) motivations and satisfactions of the telling. Only when the motives of the comic are understood, he explains, can we locate the secret connections between the dirty joke and the response of the audience. Most frequently, the joke-teller is using the form of comedy in order to exteriorize or "get rid of" unpleasant truths and experiences, and the joke is a means by which he can "pass on the blow" and, in the process, slough off some anxiety onto his listener-victims.

The best contemporary example of the compulsive joke-teller is prob-

ably the stand-up comedian. Legman has a lot to say in this volume about stand-up comics like Lenny Bruce, whose delivery he describes as full of "painful enthusiasm, almost hysteria" (23); a more familiar example might be the cringingly ebullient Robin Williams. But most public joke-tellers are not so successful, Legman reminds us. "Most of them and most of their 'acts' fail, and their little hour on the stage is mercifully brief" (40). In his characteristically eloquent way, he explains how the compulsive joke-teller—particularly the public one—"is only attempting to reassure himself on the subject of his most desperate fears, whistling under his rictus-mask in the darkened parts of his own soul that nauseate and frighten him the most" (19).

No Laughing Matter isn't just a book about dirty jokes, however—it's a book about *really* dirty jokes. Whilst acknowledging that almost all humor is composed of an "inevitable and hostile infantile anality" (891), Legman confesses that the jokes in this volume are more hostile and more anal than most. He runs through a grotesque litany of stories about fecal matter, necrophilia, venereal disease, urine, and sputum, describing their usual style of delivery, in which the most repulsive details are repeated again and again, as if to bring the listener "as close as possible to vomiting" (382).

Such jokes are obviously not pleasant. So why do people tell them? According to Legman, the prevailing emotion behind such jokes is fear—in particular, fear of being driven away and denied (he points out that the "*casting off of fear* by rollicking in its details is the one classic function of jokes and humor generally" [302, emphasis in original]). Stories about unusual sexual practices, for example—like necrophilia, "fart-smelling," scatology, and undinism (especially jokes about women pissing in men's beards and faces)—are, as Legman explains, "rationalizations, under the mask of humor, of a perverted reality that people who accidentally come in contact with would prefer to laugh about than have to take in all its ugly seriousness" (885). The teller of such jokes, explains Legman,

> is not really at ease in the slime and blood and pus with which he often splatters his stories for cake-topping, in the disfigurements and castrations he habitually uses for décor, his face more often than not contorted into a fixed grin as he crashes on: a grin representing his nervous and guilty enjoyment of his listeners' unease. From any point of view, the scene is like the definition of a German joke: "*No laughing matter.*" (32)

4.

One of the longest and most controversial sections of the second volume deals with jokes on the topic of homosexuality, which happens to be

Legman's particular *bête noire*. As in the first volume, his attitude is aggressively anti-homosexual. By way of example, consider the following two examples of homosexual jokes—both from the category of Pedication, and both with the same punchline—along with Legman's discussion of their rationale:

> Two sailors are talking aboard ship. "You know," says one, "the best tail I've ever had was right here on this ship." "No shit?" "Well, not really enough to matter."

According to Legman, jokes like this one disguise homosexual fears and inclinations. This particular joke touches, "lightly but certainly," on "the one most inacceptable element in pedication: the dirtying of the active male's penis with feces. This does not always happen, but once is enough. This is also why cultivated men will not perform pedication with women" (151). Legman also believes that the purely linguistic approach to the homosexual act of pedication functions as a sort of "linguistic tongs," which can then be "used by the joke-tellers to deal antiseptically with a subject obviously of great interest to them, yet from which they must pointedly withdraw insofar as any 'personal' interest is concerned" (147). It's for this reason, he explains, that many people will tell homosexual jokes "with exaggerated homosexual intonation and gestures, though the same persons will often not bother to attempt dialect effects in telling, for example, comedy Jewish, Negro or Italian stories" (147).

> A cowpuncher rode in off the range, on a charcoal grey horse, with a pink dotted-swiss saddle, and tied its satin reins to the hitching rail at the saloon. Then he pranced inside, adjusted his lavender chaps, and said in a high mincing voice, "Where'th the fellowth?" The bartender said, "They're out at Boot Hill, hanging a queer." So the cowboy boomed in a deep voice, "NO SHIT?"

This joke is included in a category that Legman calls The Tough Faggot. Such jokes, he argues, "neatly unveil what is perhaps the commonest of all homosexual disguises: that of super-toughness—the cowboy, the truck-driver, the athlete, the prize-fighter and bullfighter, the explorer and animal-killer, and the professional soldier; all of those professions which turn out, on closer study, to be the rendezvous largely of homosexual sadistic types in flight from any public recognition of their essentially sexual neurosis" (82). This kind of arch-Freudian "diagnosis" turned many readers off the book and made it difficult for others to take it seriously. R. Z. Sheppard in *Time* described Legman as "the Joe McCarthy of heterosexuality, who looks for gays under every bed" (97). He also accused Legman of harboring an idealistic, Victorian view of the purity and transcendence of womanhood, of believing a woman should be kept at home, preferably barefoot and pregnant.

Mikita Brottman, Ph.D.

It's certainly true that Legman endorses an enthusiastically hetero-sexual stance, and refers more than once to his conviction that homosexu-ality is a dangerous "perversion" that can be cured. Those who knew him point out that, as a long-time champion of the love of women, women's bodies, heterosexuality, and motherhood (and maybe as a zero on the Kinsey scale—i.e., *totally* heterosexual), Legman seemed to associate heterosexual-ity with birth, life, and nature, and (male) homosexuality with death, ste-rility, and the worst of mechanized civilization and war. A proponent of traditional psychoanalysis, which he tied very closely to his own enthusias-tic heterosexuality, Legman was deeply apprehensive of a sexual orienta-tion that—however inappropriate this may seem to us today—he had come to associate with misogyny and brutality.

5.

Reviewers were baffled and shocked by these volumes, as by most of Legman's work, and their responses were almost entirely negative. One of the most common complaints about both volumes was that Legman's cat-egorization of jokes according to their subject matter doesn't take into account the fact that dirty jokes are mainly an oral phenomenon, told by particular people in particular situations, whose meaning often depends on the context in which they're told. The reviewers pointed out that clas-sifying jokes according to their overt subject matter really makes little sense if, as Legman is claiming, most of them have meanings that are im-plicit, proverbial, or metaphorical in nature.

Philip French, writing in the *New Statesman,* also suggests that this kind of vague theme-indexing lays itself open to duplication—a criticism that's often made about Legman's work ("to read it once is to read it twice," commented someone else about the book). French complains that a slight change of emphasis or approach could easily lead the same joke to appear in a number of different sections. "Moreover," adds French, "he is infinitely repetitive; indeed, one gets the impression in reading the book from cover to cover that one is doing something the author hasn't done" (278).

Charles Rycroft, in the *New York Review of Books,* considered Legman's knowledge of Freudian psychoanalysis to be simplistic and inadequate, and pointed out that many of his interpretations seem broadly drawn and rather unsophisticated. Legman seems unaware of the more subtle work Freud did after the 1920s, and "is totally ignorant of the developments [in psychoanalysis] of the last fifty years" (Rycroft 24). And like all the other reviewers, Rycroft found Legman's eccentric style and intemperate lan-guage so difficult to put up with that he considered it enough to make the reader "lose all faith in his judgment" (25).

Perhaps the subject matter and style of his work made Legman rather an easy target of derision, and it's true that he wanders from his main theme from time to time. But what the reviewers seem to have missed is that the main goal of Legman's scholarship is the reintegration and assimilation of apparently disparate things, so they can be seen as existing in a complex political, social, and psychological continuum—"a world where *everything counts*," as Bruce Jackson puts it (112). Legman's aim is to understand how and why everything links and locks together, and this especially includes the way in which mimetic representations or articulations relate to physical and somatic acts.

It's also rather interesting that all reviewers seem to have been taken aback by the fact that, throughout the book, its author constantly offers evaluations of behavior and situations, and frequently makes value judgments, which "serious" scholars apparently shouldn't do. "This is unfashionable now," writes Legman elsewhere, "but is the only responsible position" (Nasso 526). And whilst it's true that Legman sometimes exaggerates the facts and makes outrageous claims, he does so only as a rhetorical device to draw attention to some particular circumstance or situation; in other words, his hyperbole is proof of his earnestness.

As Bruce Jackson points out, the title of Legman's book—*Rationale of the Dirty Joke*—was consciously and deliberately chosen, and this is something else that all its reviewers seem to have misunderstood. Everybody seems to have assumed that the point of these volumes was to *explain* the dirty joke—something that would, as Legman's detractors rightly suggest, involve a psychological study of both teller and listener, and a performative analysis of the context in which the joke is being told. But Legman is doing something rather more subtle; he's trying to understand what the dirty joke *itself* is trying to explain—to understand the rules of the world *within* the joke. In other words, he wants to explain how the dirty joke makes *rational* something apparently *non-rational* (the title is, after all, *Rationale of the Dirty Joke*, not *Rationale for the Dirty Joke*). Legman explains in his introduction to *Rationale* that the title indicates that the book is an attempt to understand how "these stories and individuals do personify what the tellers and singers well know to be real but inexplicable peculiarities of human behavior, which they are attempting somehow to fit into a rational view of the world, whether as horror or as humor" (*Rationale* 22).

Finally, the sneering reviews of *Rationale* give no credit at all to the enormous amount of work involved in simply collecting and categorizing thirty years' worth of dirty jokes—involving, as Legman put it, daily struggles "under the gross tonnage of 60,000 index cards and some 10,000 books" (*Rationale* 14). However fruitless this work may seem to some, it's proved enormously valuable to folklore scholars, sexologists, and lexicog-

raphers, and was completed, as Bruce Jackson has pointed out, in the face of great contempt from established academics and under a set of financial strictures that most scholars would find totally disabling. Legman worked without university funding, research grants, photocopying facilities, or academic recognition—something which gradually became an issue of great acrimony to him, leading him to produce great scornful passages of vitriol about "university professors," especially those in folklore departments.

In this, however, he was perhaps his own worst enemy. Since he so often attacked scholarship with vigor and glee, it was little wonder he was never offered support, financial aid, or gratitude. "I write the way I do because, like Luther, 'I cannot other,'" he wrote to Kinsey's successor, Paul Gebhard—but, in writing this way, he regularly offended his academic peers with his bitter asides about the state of current scholarship and angry rants about corrupt professors who all fund one another's pet projects. "I have never been able to bend the knee and lick the shoe properly, and so the foundation jobs and articles always go to someone else," he wrote to Gebhard. "How much work do I have to do, myself, before somebody gives *me* an honorary degree?"

Perhaps what made his colleagues most uncomfortable, however, was the way in which, by imbuing his scholarship with his own erratic consciousness, he abandoned the distance that most scholarly writers need to feel comfortable and safe when they're writing about sex.

6.

After a lifetime spent studying them, Legman came to the conclusion that dirty jokes are rather pathetic, and what they have to reveal about the human condition is dreadfully sad. He once confessed in an interview that he didn't like jokes at all, and rarely told them. "'After they get that first nervous laugh, they're depressing,' he said. 'I'm a poor raconteur and I never laugh. Maybe a little titsatibitsa laugh, but yokchatabotcha—hah hah hah—no'" (Vinocur 126).

WORKS CITED

French, Philip. "Digging the Dirt." Review of *Rationale of the Dirty Joke,* by Gershon Legman. *New Statesman,* August 29, 1969, pp. 278–279.
Jackson, Bruce. "Legman: King of X700." *Maledicta* 1 (winter 1977), pp. 111–124.
Legman, G. *Rationale of the Dirty Joke: An Analysis of Sexual Humor.* First Series. New York: Grove, 1968. Reprinted, 1971, paperback; London: Jonathan Cape, 1969; London: Panther, 1972, 2 vols., paperback. German translation, Hamburg: Hoffmann und Campe, 1970. French translation, Paris: R. Laffont, 1971. Italian translation, Rimini: Guaraldi, 1972–73, 2 vols.

————. *No Laughing Matter: An Analysis of Sexual Humor.* Second Series. New York (Wharton, N.J.): Breaking Point, 1975. Reprinted, London: Hart-Davis MacGibbon, 1978. Bloomington: Indiana University Press, 1982.

[Nasso, Christine]. "G(ershon) Legman." In Christine Nasso, ed., *Contemporary Authors* (rev. ed., vols. 21–24), pp. 525–526. Detroit: Gale Research, 1977.

Rycroft, Charles. "What's So Funny?" Review of *Rationale of the Dirty Joke,* by Gershon Legman. *New York Review of Books,* April 10, 1969, pp. 24–25.

Scott, Janny. Obituary. *New York Times,* March 14, 1999, p. 49.

Sheppard, R. Z. "The Japes of Wrath." Review of *No Laughing Matter,* by Gershon Legman. *Time,* November 10, 1975.

Vinocur, John. "Gershon Legman Doesn't Tell Dirty Jokes." *Oui,* March 1975, pp. 94–96, 126–128.

Sex and Humor

Selections from The Kinsey Institute

UNKNOWN, UNITED STATES
Baby "reading" *Sexual Behavior in the Human Male,* 1948
Gelatin silver print
2¹/₄" x 4"
KI-DC: 44933
Donated in 1948

The publication of Alfred Kinsey's first book on sexual behavior (soon known as the "Kinsey Report") inspired numerous jokes, cartoons, parodies, and novelty items. The book quickly became a bestseller, although it is doubtful that many people actually read the entire 804-page volume. According to this photograph, taken the same year the book was published, even babies wanted to read what the famous Dr. Kinsey had to say about male sexuality.

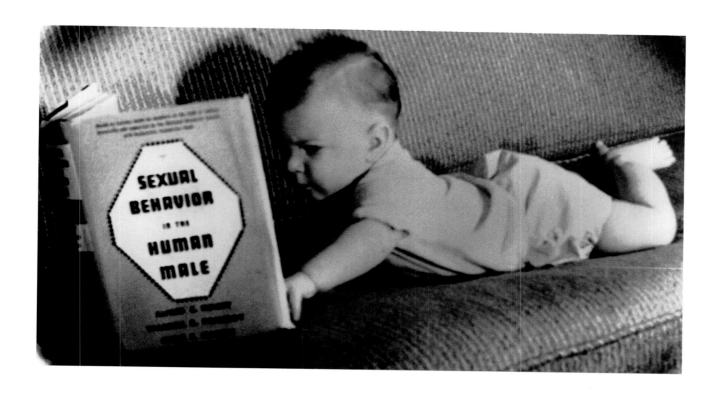

PLATE 2

UNKNOWN, UNITED STATES
Comic cards, mid–20th century
Printed cartoons in envelope
2³/₄" x 4"
A630R A887a–m/KI 2905a–m
Donated in 1977

A dozen of these wallet-sized cards, packaged in a plain envelope, could be purchased for a dollar. The sexual or scatological jokes were familiar standards, such as the World War II–era cartoon featuring a sailor who exclaims to the startled woman sharing his bath, "And that, Miss Jones, is how a torpedo works!" The Institute's collection contains a ceramic ashtray and a handkerchief that feature the same cartoon.

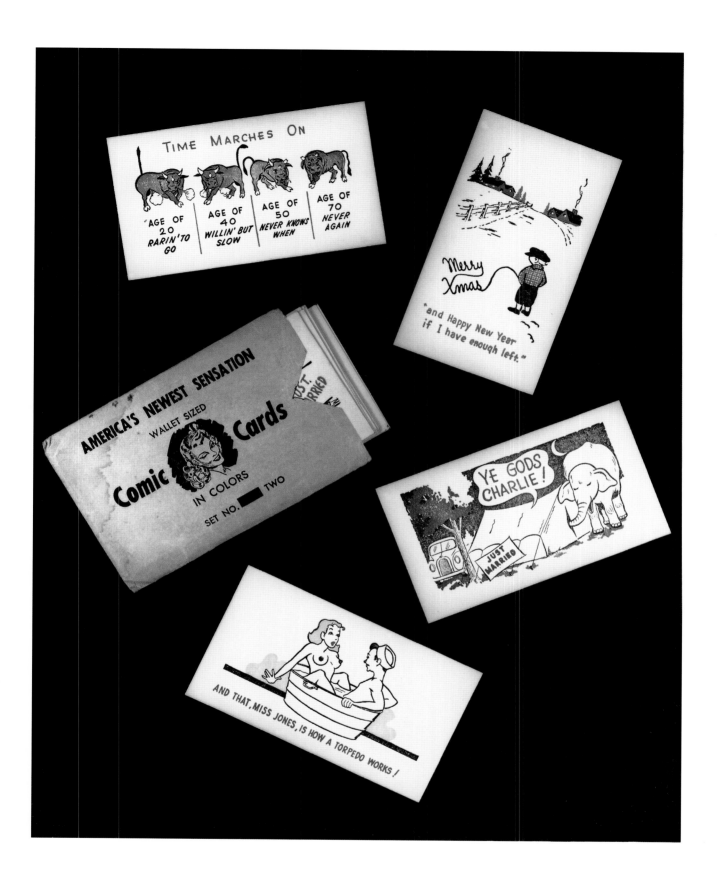

PLATE 3

UNKNOWN, UNITED STATES
Eight-pagers, 20th century
Printed comic books
3" x 4–4½"
Kinsey Library
Various donation dates

Millions of these cheap, pocket-sized erotic comic books were clandestinely produced in the United States from the late 1920s into the 1960s, though their heyday came during the years of the Depression and World War II. Also known as "Tijuana Bibles," they were inspired by newspaper comic strips and often featured the same familiar characters. The anonymous artists who drew these comics attracted readers by placing these characters, as well as famous movie stars and well-known public figures, in humorous and explicitly sexual scenarios.

58 Selections from The Kinsey Institute

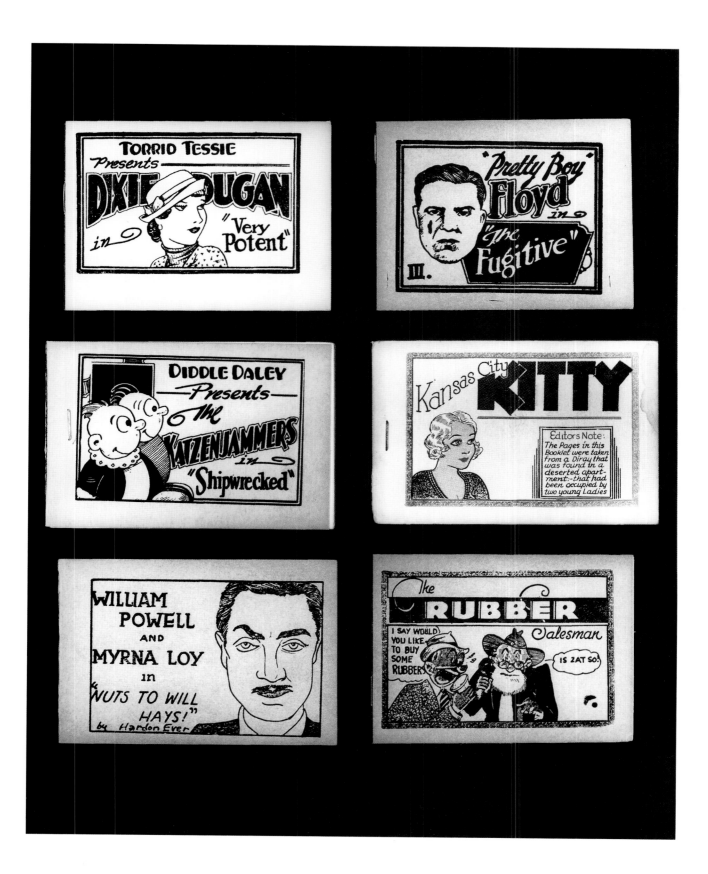

PLATE 4

UNKNOWN, UNITED STATES
Merry Christmas, 1930s
Postcard
4⁷/₈" x 3¹/₈"
Unnumbered
Donated in 1946

The style of drawing and the explicitly sexual subject matter of this
holiday card bear a close similarity to the popular erotic comic books
known as eight-pagers. The illustration has little to do with Christmas,
apart from the holly wreath hanging on the wall behind the copulating
couple.

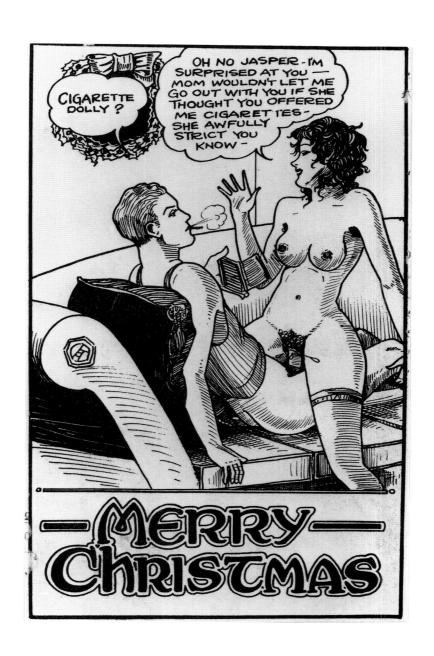

PLATE 5

UNKNOWN, EUROPE
Child revealing couple in bed, date unknown
Engraving
2¹/₄" x 3³/₈"
Kinsey Library E 710 Alg
Donated in 1950

These two engravings are from a bound collection of thirty-seven erotic plates owned either by Napoleon's Marshal Jean Baptiste Bessières or his son Napoleon Bessières. The elder Bessières led military campaigns in Egypt, Austria, Spain, and Russia and served as commander of Napoleon's imperial guard. This volume of erotica is bound in red leather that is decorated with the emperor's emblem in gold leaf. Although the book itself dates from the early nineteenth century, the individual engravings represent the work of various artists from the eighteenth century and earlier.

PLATE 6

UNKNOWN, FRANCE
Man examining woman's buttocks with eyeglass, c. 1774
Engraving
5$^{1}/_{8}$" x 3$^{3}/_{8}$"
Kinsey Library E 710 Alg
Donated in 1950

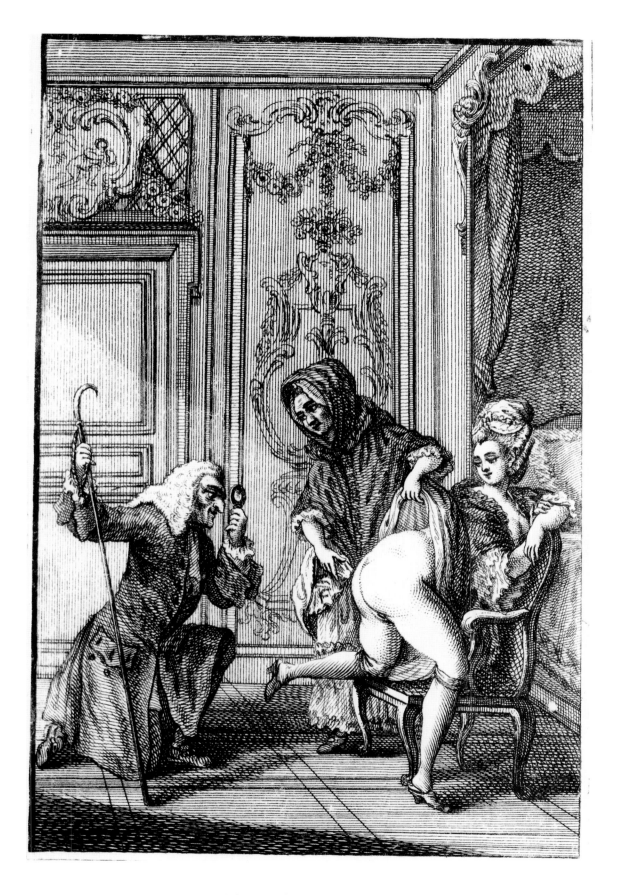

PLATE 7

UNKNOWN, FRANCE
Group sex scene in outdoor setting, date unknown
Engraving
4" x 2$^{13}/_{16}$"
A397R A072
Donated in 1947

This sexual encounter is so well choreographed that the men are ejaculating simultaneously. The poem does not refer specifically to this amusing image, but instead takes a more serious tone, with a reference to violent rape. "Ajax qui viola Cassandre" refers to the tragic characters from Greek mythology—the arrogant warrior Ajax and Cassandra, the daughter of Priam, the last king of Troy. Ajax disgraced himself by invading the temple of Athena to rape Cassandra, who had sought sanctuary and protection with the goddess.

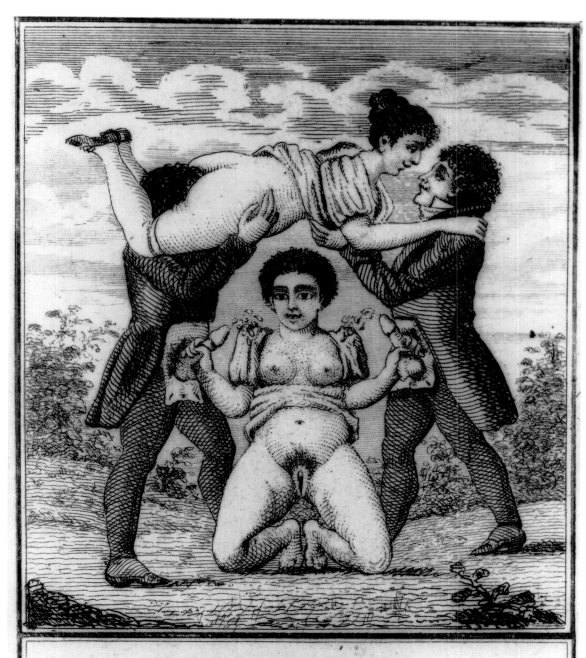

La beauté n'est qu'une foutaise,
C'est l'idole d'un bandé à l'aise,
Un bon fouteur à mon avis
Jusque sur l'autel en doit prendre;
A jax qui viola Cassandre.
Certes bandait mieux que Paris,
Merveille de la terre ô délicieux con!
Monvit rompant son frein, s'allonge à ce seul nom.

PLATE 8

UNKNOWN, UNKNOWN
Woman falling over fence (stereocard), 19th century
Gelatin silver print
$3^{1}/_{8}$" x $2^{5}/_{8}$" (image)
KI-DC: 67634
Donated in 1947

Stereo photographs that appear three-dimensional when seen through special viewers were a popular form of entertainment in the nineteenth century, and have continued to be produced to the present day (several generations of twentieth-century children have played with View-Masters, and today there are magazines and Web sites for aficionados of stereo photography). Erotic imagery was common from the beginning, including humorous scenes such as this one showing a woman whose lack of undergarments is revealed when she tumbles over a fence.

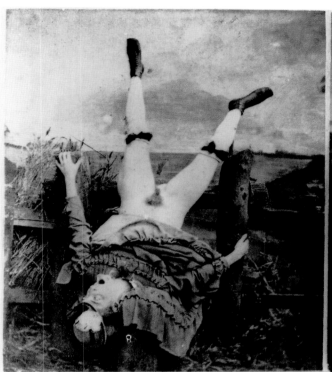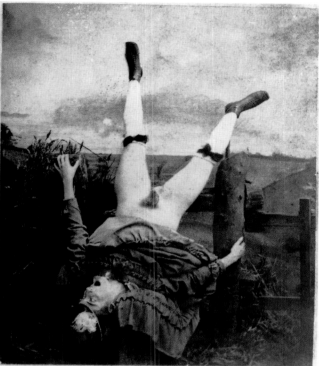

PLATE 9

UNKNOWN, FRANCE
Couple in coitus with hat and umbrella, 1950–1955
Gelatin silver print
3³/₄" x 4³/₄"
KI-DC: 6613
Donated in 1964

This urban couple have put their newspaper aside to concentrate on the activity at hand, but they haven't taken the time to remove their shoes and hose. This is clearly a staged scene, judging from the deliberate placement of the props (especially the hat perched on the woman's high-heeled shoe) and the rather sterile space created by the white cloths placed on the floor and wall.

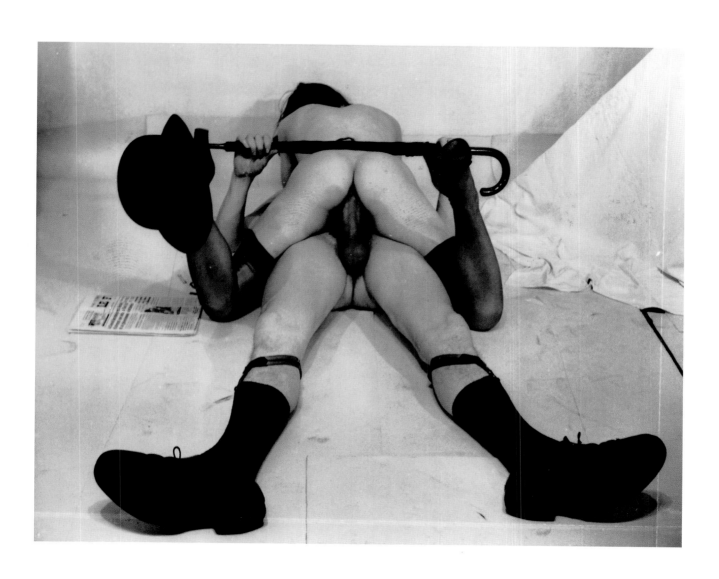

PLATE 10

UNKNOWN, UNITED STATES
Man and woman posed as Archer and Water Bearer, 20th century
Gelatin silver print
$3^{5}/_{8}$" x $4^{7}/_{8}$"
KI-DC: 59710
Donation date unknown

Although the anonymous creator of this photograph appears to be
continuing a long tradition of classical nudes, the placement of the
ceramic water jugs next to the woman's breasts and the incongruity of a
modern man in the minimal costume of the Archer lead the viewer to
"read" this image as a humorous scene.

PLATE 11

UNKNOWN, JAPAN
Men and women as sumo wrestlers, 20th century
Ink and colors on silk
9½" x 12"
A250R A183.1
Donated in 1953

This is the first in a series of six scenes representing the battle of the sexes as a sumo wrestling match. The man with the most impressive penis is competing against the most ample woman. The woman initially fends off the man, but eventually coitus is achieved and the man is declared the victor by the referee.

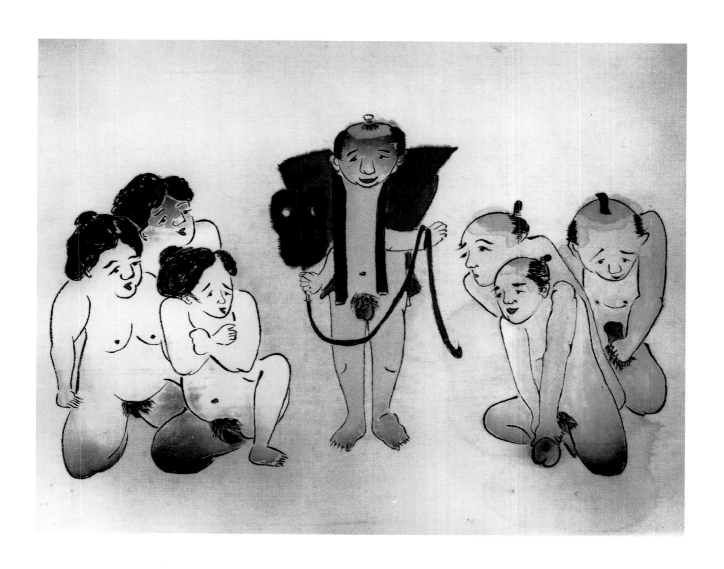

PLATE 12

UNKNOWN, JAPAN
Woman inserting dildo in giant vagina, 20th century
Ceramic, paint
6" x 8" x 4"
A250R A034.1/ISR 518
Donated between 1951 and 1959

The hairstyle and body type of this female figure suggests that she is meant to resemble a sumo wrestler. Women's sumo wrestling is not unknown in Japan, but it is seen as a form of erotic entertainment rather than a serious sporting event. This woman needs the strength of a wrestler to hold the massive phallus and thrust it into the huge vagina beside her.

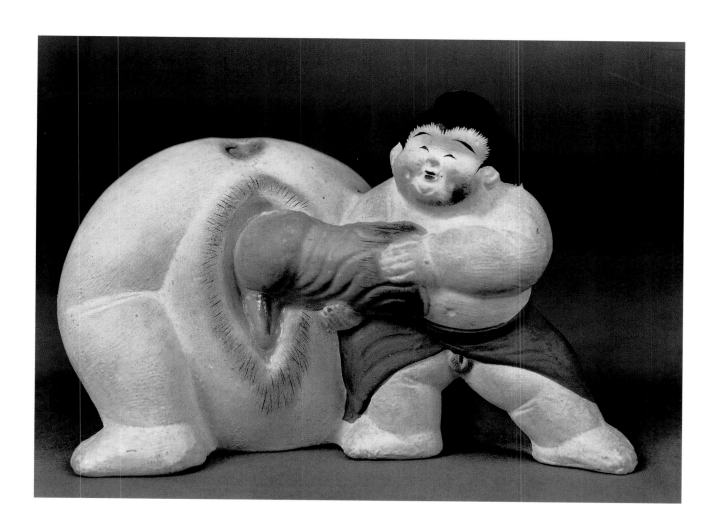

PLATE 13

UNKNOWN, JAPAN
Male and female monkeys, 20th century
Clay
7¹/₄" x 3¹/₂"
A250R A153.1/ISR 1311
Donated in 1972

These figurines were brought to the United States as "war booty" after World War II. The exaggerated genitalia suggest that they may have been intended as offerings to be left at a Shinto shrine, although monkeys are more commonly associated with Buddhism. While these may not have been created specifically as humorous objects, the maker's sense of whimsy is evident. The male monkey has difficulty putting his arms around his gigantic penis, while the female has crossed her hands demurely in front of her vulva.

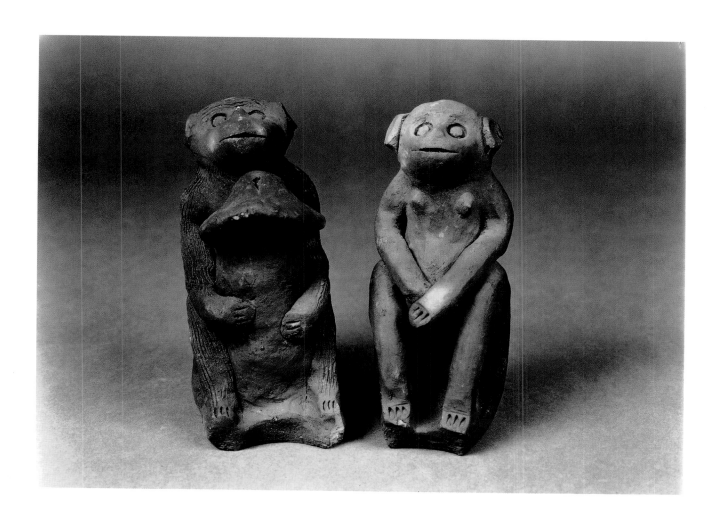

PLATE 14

MICHEL FINGESTEN (1884–1943), GERMANY
Woman with monkey, 1920s
Engraving
2³/₄" x 6³/₄"
A402R F4973.2
Donated in 1948

Collectors of erotic books often commission artists to create personalized bookplates for their volumes. The German printmaker Michel Fingesten created several thousand engraved bookplates during his lifetime, which sadly ended prematurely in an Italian concentration camp in 1943. Humor is frequently found in his work, as demonstrated by these two engravings. In the first, a monkey's long tail becomes a substitute for a penis, while an oversized erect phallus functions as a ship's mast in the second work.

PLATE 15

MICHEL FINGESTEN (1884–1943), GERMANY
Navigare necesse est (bookplate for Gianni Mantero), 20th century
Engraving with watercolor
7¹/₈" x 9¹/₈"
A402R F4973.43
Donated in 1981

Selections from The Kinsey Institute

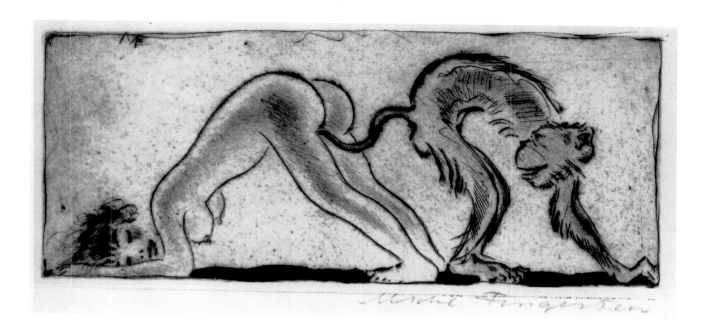

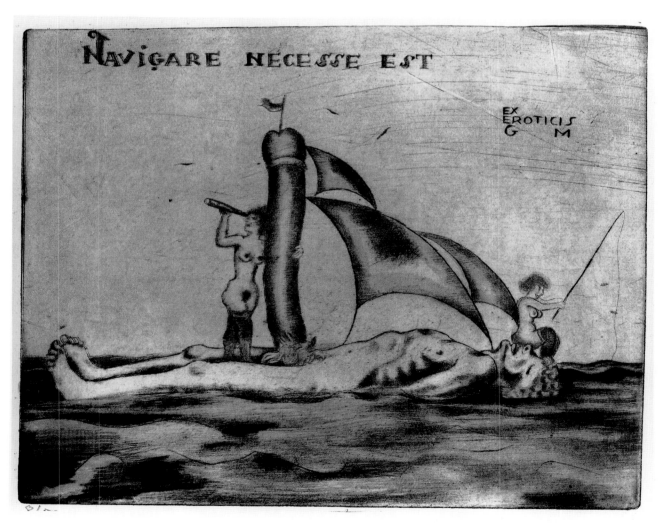

PLATE 16

WILLIAM THOMAS, UNITED STATES
Augmented male physique image, mid–20th century
Gelatin silver print
9¼" x 7"
Unnumbered
Donated in 1949

Male physique photographers produced thousands of images for the mail-order market, with the heyday of the genre occurring during the 1950s. Supposedly produced for artists and bodybuilders, these images of handsome, muscular men were also popular with gay men. Although the models did not engage in sexual activity and often wore G-strings rather than posing in the nude, both consumers and the authorities regarded these photographs as erotic images. During the conservative post–World War II era it was not uncommon for physique photographers to have their studios raided by police, who suspected them of sending obscene materials through the mail.

Thomas altered this photograph by drawing strings of beads and other jewelry on the nude bodies of the men, transforming this ostensibly masculine representation into an exotic image that suggests transvestism or homosexuality. The work was then re-photographed to create the illusion that the jewelry was part of the original image. The identity of the original photographer is unknown.

PLATE 17

UNKNOWN, UNKNOWN
Buttocks in water, mid–20th century
Gelatin silver print
$4^3/_8''$ x $6^3/_8''$
KI-DC: 51763
Donated in 1951

The person shown in this photograph could be male or female, but knowing the sex is not necessary to appreciate the photographer's visual joke, in which the human body is used to suggest a round, ripe fruit ready to be consumed.

PLATE 18

UNKNOWN, UNKNOWN
Penis "face" with glasses and pipe, date unknown
Gelatin silver print
4½" x 3⅝"
KI-DC: 44918
Donated in 1947

Artists have often used the penis to represent other objects, as numerous pieces in the Institute's collection illustrate. Several photographs depict a woman with knife and fork, looking hungrily at the plump "sausage" that lies on her plate (see John Bancroft's essay, figure 4). In this image, the addition of a pair of eyeglasses and a pipe has transformed the penis and testicles into a comical human face.

PLATE 19

WILLIAM DELLENBACK (1917–2000), UNITED STATES
Female figure made out of turnips, 1952
Gelatin silver print
$9^{1}/_{4}"$ x $6^{3}/_{8}"$
Unnumbered
Acquired in 1952

When William Dellenback was hired by Alfred Kinsey to be the Institute's staff photographer in 1949, his duties were not only to document the activities of the researchers, but also to photograph materials that could not be acquired for the Institute's art collection. Preserving this particular "sculpture" for the collection would have been difficult, but Dellenback's photograph has survived to document its temporary existence. The research collection includes many examples of homemade erotica, from amateur photographs and drawings to paper, ceramic, and hand-carved wooden figures. It is not known whether Dellenback was also the creator of this piece of organic erotica.

PLATE 20

UNKNOWN, MEXICO
Fuente del Niño, 1950s
Color postcard
5½" x 3⅜"
Unnumbered
Donated in 1958

These two pieces show the use of "bathroom humor" to illustrate commercial postcards. Scatological and sexual humor are closely linked, as both refer to physical functions that are common to all human beings, yet are often sources of social embarrassment. The boy drinking from the fountain knew he was consuming water, but the tourists who would have purchased this postcard were meant to be amused by the suggestion that he was drinking from a urine stream. The German cartoon of the man and woman sharing a large chamber pot bears the caption "Zwei Seelen und ein Gedanke" (two souls and one idea). The meaning of the glowing mug overhead is unknown—possibly they are feeling the effects of too much beer the night before.

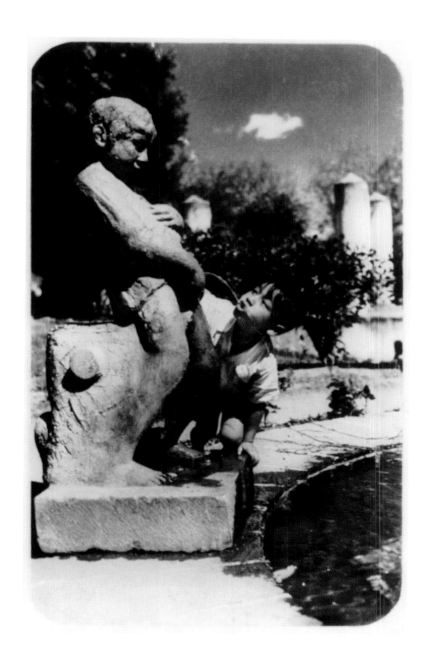

PLATE 21

UNKNOWN, GERMANY
Zwei Seelen und ein Gedanke, early 20th century
Color postcard
$3^{5}/_{16}$" x $4^{13}/_{16}$"
Unnumbered
Donated in 1946

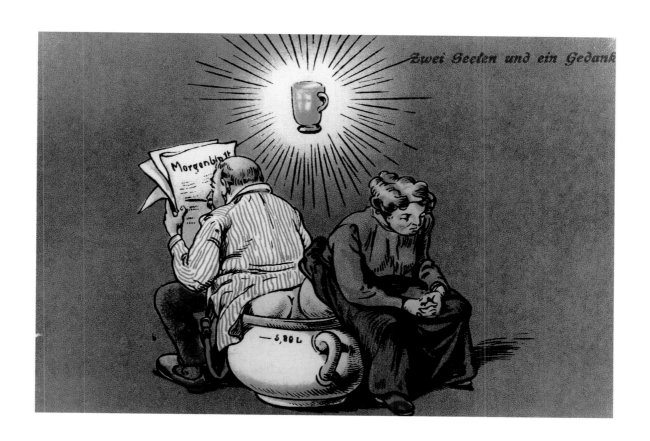

PLATE 22

UNKNOWN, UNITED STATES
"Well—What the Hell Are You Staring At?" 1940s
Ink, colored pencil
6⁷/₈" x 9"
A630R A764
Donated in 1981

The presence of women in the armed forces during World War II inspired cartoonists to envision the humorous situations that could arise as women entered a male-dominated arena. The artist who drew this image was probably inspired by a published cartoon in which a man and woman in uniform are using the facilities in a men's restroom—the woman looks over as she awkwardly attempts to straddle the urinal and comments, "That's a mighty handy little gadget you have there, sailor." In this version, the woman in her Navy uniform is not admiring the startled sailor standing at the next urinal but instead reacts to his wide-eyed stare by asking impatiently, "Well—what the hell are you staring at?"

PLATE 23

THOMAS ROWLANDSON (1756–1827), ENGLAND
The Sanctified Sinner, late 18th or early 19th century
Engraving (copy)
5⅞" x 4" (image and text)
A371Q R8831.3
Donation date unknown

Thomas Rowlandson planned to make his living as a portrait painter. However, he found he had a talent for caricature, and in eighteenth-century England there was a ready market for engravings that poked fun at British society. Members of the clergy were popular targets for satire, as it was a common opinion that many supposedly devout men indulged in behaviors that they preached against from the pulpit. In Rowlandson's depiction of a clergyman being masturbated by a young woman, the hypocrisy of this act is emphasized by the angry face of the man watching the couple from the window. The poem that accompanies the image reiterates the message of Rowlandson's engraving:

> For all this canting fellows teaching
> He loves a girl as well as preaching.
> With holy love he rolls his eyes,
> Yet view his stout man Thomas rise.
>
> 'Tis sure enough to make it stand
> To have it stroked by such a hand.
> When flesh and spirit both combine
> His raptures sure must be divine.*

*Transcription from H. S. Ashbee, *Index Librorum Prohibitorum: Being Notes Bio-biblio-icono-graphical and Critical. on Curious and Uncommon Books* (New York: Documentary Books, 1962), pp. 351–352.

THE SANCTIFIED SINNER.

For all this canting fellows teaching
He loves a girl as well as preaching
With holy love he rolls his eyes.
Yet when his stout man Thomas rise.
Tis sure enough to make it stand
To have it stroked by such a hand
When flesh and spirit both combine
His raptures sure must be divine

PLATE 24

UNKNOWN, FRANCE
Crispation nerveuse, 19th century
Colored lithograph
12½" x 9⅞"
A397Q A0001.8
Donated in 1964

The French word "crispation" means "contraction" or "shriveling up," which explains the anxious look on this man's face as a young woman performs fellatio on him. In the nineteenth century colored lithographs such as this one were often sold as portfolios of erotic prints. This work bears a close resemblance to the lithographs of French artist Achille Devéria (1800–1857), whose explicitly erotic images were printed in small, private editions for a select clientele.

CRISPATION NERVEUSE

PLATE 25

UNKNOWN, FRANCE
Toutou, 1870
Watercolor
7⅝" x 5½" (image)
A397Q A010.1
Donated in 1947

The subjects of this watercolor appear to be domestic servants who have paused in their duties to take advantage of the opportunity for a "quickie" (note the plate tucked under the man's arm). The word "toutou" is a French term for "doggie," a reference to the sexual position of the couple, as well as to the animalistic urgency of the furtive act.

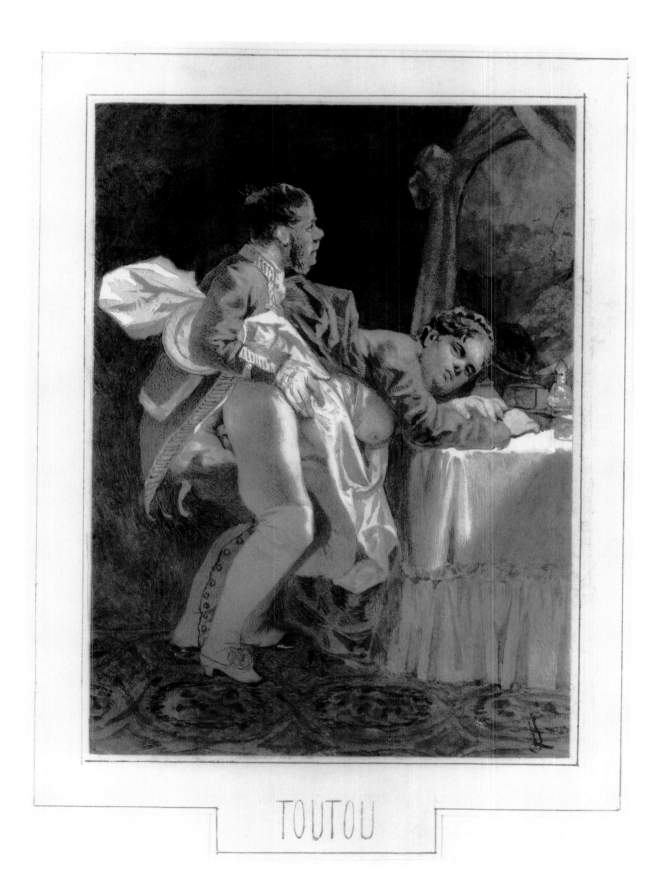

TOUTOU

PLATE 26

UNKNOWN, UNKNOWN
Man and woman in coitus on couch, mid–20th century
Graphite
8⅝" x 11⅛"
Anon. Art Set #25H #7
Donation date unknown

This is one of twelve drawings showing a modern couple engaged in various sexual acts on the living room couch while one of them tries to read a book (the book changes hands from drawing to drawing). The artist seems to be saying that in today's fast-paced world, sexual encounters must be combined with other activities that may be resumed as soon as the slightly rumpled clothing is straightened. In the final sketch, the man has resumed his reading, leaving his partner to bring herself to orgasm at the other end of the couch.

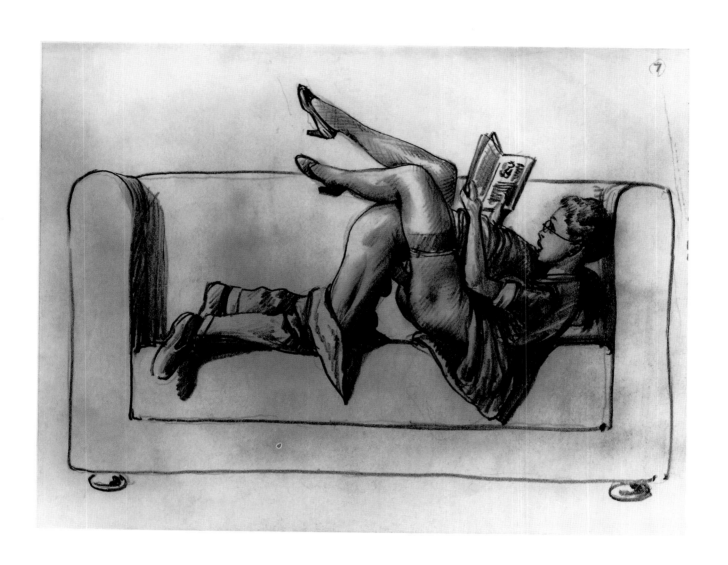

PLATE 27

CYRIL SATORSKY (1927–), ENGLAND
Racing His Snails, illustration from *A Pride of Rabbis,* 1970
Linocut
13¼" x 8¼"
A371R S2536.1
Donated in 1972
Copyright © 1970 by Cyril Satorsky. All rights reserved.

This work is one of thirteen illustrations created by printmaker Cyril Satorsky for his book *A Pride of Rabbis,* published by Aquarius Press in 1970. The artist has chosen to illustrate the familiar theme of a man with an unusually large penis. However, the unique addition of snails slowly crawling along its length indicates that the proud owner of the penis is not only well endowed, but also has an impressive ability to maintain an erection.

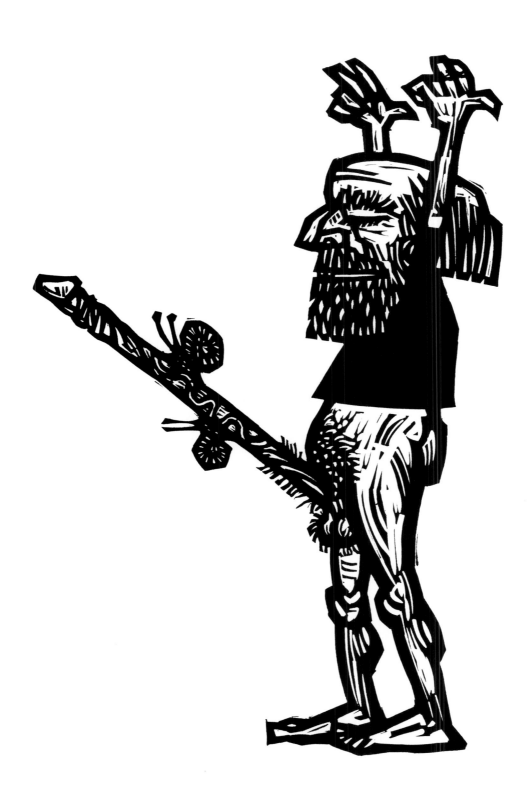

PLATE 28

GRAEWOLF, UNITED STATES
Men Fishing, mid–20th century
Graphite, colored pencil
$7^{7}/_{8}$" x $10^{1}/_{2}$"
A630R S4357.3
Donated in 1962

This image derives its humor from the absurd idea of men using their erect penises as fishing poles. The exaggerated physiques of the male figures, drawn in a comic book style, seem well-proportioned given the prominence of the men's "rods." Even the fish that is swimming toward the men has a phallic appearance.

PLATE 29

UNKNOWN, GERMANY
Phallic traveler (from album of drawings), c. 1850
Graphite
$7^{1}/_{4}$" x $9^{1}/_{4}$" ($9^{1}/_{4}$" x $12^{3}/_{4}$")
A402Q A007
Donated in 1977

The anonymous nineteenth-century German artist who drew this scene
chose to personify the penis as a jaunty traveler, equipped with pipe,
hat, walking stick, and knapsack. His path is marked by penis-shaped
posts, and he is headed toward a strange castle that features several
phallic towers. The album contains twenty erotic drawings by this artist,
including a depiction of a circus performer balancing a board that holds
two tankards of beer on his erect penis while he walks on stilts, and
another of a small man attempting to copulate with a rather large cow.

PLATE 30

UNKNOWN, FRANCE
Le fakir ou la force de volonté (The fakir or the strength of will), c. 1942
Ink
7$\frac{1}{8}$" x 5$\frac{3}{4}$" (image)
A397R A047b
Donated in 1983

This cartoon drawn by a French diplomat during World War II takes the comic idea of the well-endowed male to new heights. His depiction of the "rope" charmer whose exceedingly long penis is sturdy enough to support the weight of a grown man is similar to other cartoons of this era that depict a "Hindu snake-charmer" coaxing his own penis to rise by playing music to it.

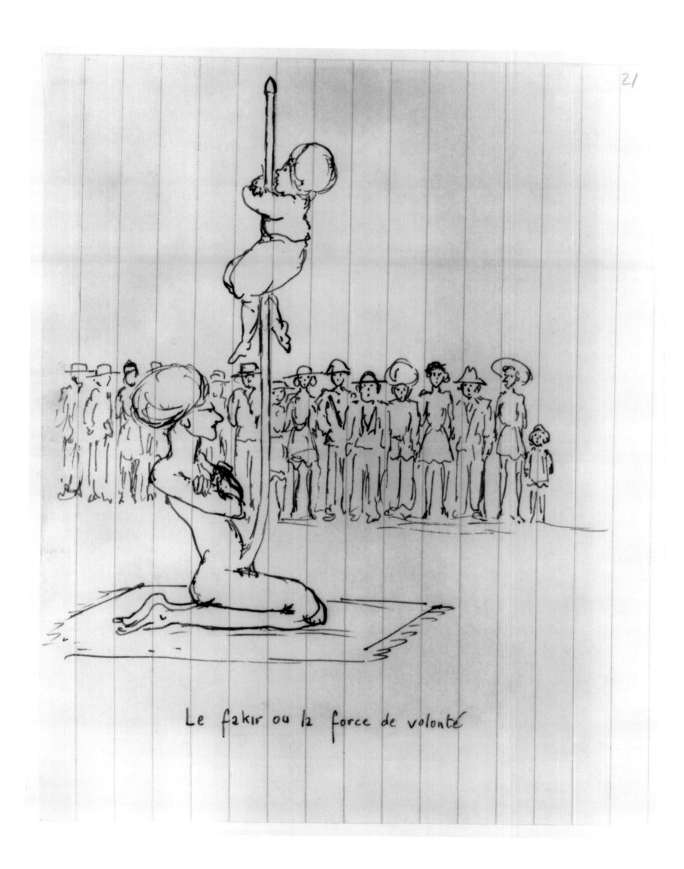

Le fakir ou la force de volonté

PLATE 31

UNKNOWN, FRANCE
Woman and phallus in 18th-century costume, 20th century
Etching
7" x 5⅛" (plate)
A397R A058b
Donated in 1985

The Institute's collection includes six signed works by this unidentified French graphic artist (who must remain "anonymous" due to the signature's illegibility). In one image the penis is personified as a well-dressed eighteenth-century gentleman who towers over his female companion with an air of great self-importance. In another, a uniformed servant stands with his trousers open in front of his elderly mistress. In this image, the relatively small size of the penis is emphasized by the actions of the old woman, who reaches out to touch the flaccid organ as she inspects it carefully through her handheld spectacles.

PLATE 32

UNKNOWN, FRANCE
Woman examining man's genitals with eyeglasses, 20th century
Etching
7" x 5" (plate)
A397R A058f
Donated in 1985

PLATE 33

UNKNOWN, JAPAN
Scene from *Yōbutsu-Kurabe* (The phallic contest), 19th century
Woodblock print
4" x 6¼"
A250Q A040a
Donated in 1954

This nineteenth-century woodblock print is a copy of a twelfth- or thirteenth-century composition depicting a phallic contest, in which the lords of the imperial court compete to see who has the most substantial and impressive penis. The ladies of the court observe from behind a curtain as the measurements are carefully taken and recorded.

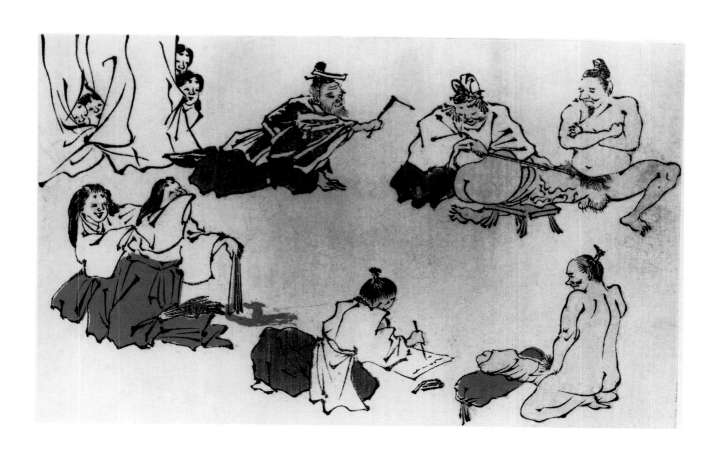

PLATE 34

EUGÈNE MODESTE EDMOND LEPOITTEVIN (1806–1870),
FRANCE
Le Jet d'eau and other images, from *Charges et décharges diaboliques,*
c. 1832
Lithograph
6³/₈" x 7⁵/₈" (image)
Kinsey Library E710 L593c
Donated in 1958

The Romantic movement in art and literature inspired erotic interpreta-
tions of devils, as seen in the Swiss artist Henry Fuseli's 1781 painting
The Nightmare, in which a demonic figure sits heavily on the torso of a
swooning woman. Lithographs depicting the lewd antics of mischievous
devils, known as *diableries* ("pranks of the devil"), were popular in France
in the 1830s. Later photographers produced stereoscopic images using
modeled figures to demonstrate the comic activities of devils in Hell.
Eugène Lepoittevin was a prolific painter as well as a lithographer, but
among his most popular works were his *Albums des diableries,* portfolios
of prints in which devils, often endowed with gigantic phalluses,
interact with young women.

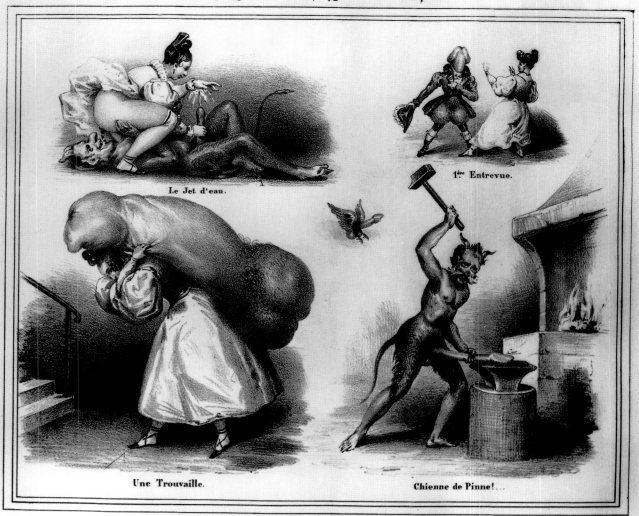

Charges et décharges Diaboliques.

Le Jet d'eau.

1ʳᵉ Entrevue.

Une Trouvaille.

Chienne de Pinne!...

PLATE 35

EUGÈNE MODESTE EDMOND LEPOITTEVIN (1806–1870),
FRANCE
Oh c'te tête! and other images, from *Charges et décharges diaboliques,* c. 1832
Lithograph
6³/₈" x 7⁵/₈" (image)
Kinsey Library E710 L593c
Donated in 1958

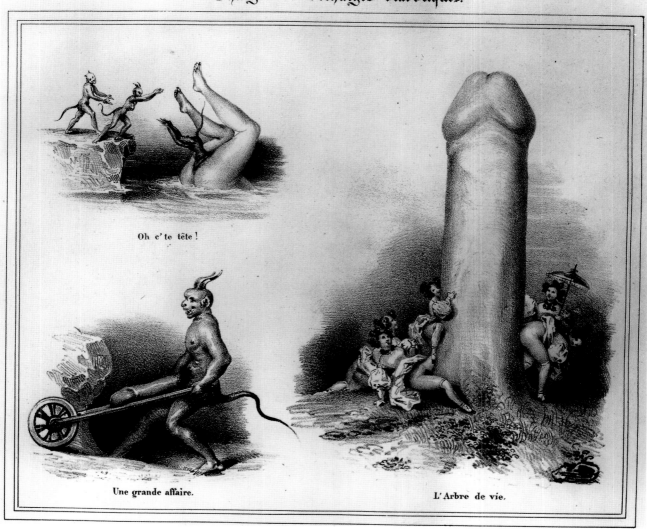

Charges et Décharges diaboliques.

Oh c'te tête!

Une grande affaire.

L'Arbre de vie.

PLATE 36

UNKNOWN, GERMANY
Soldier carrying his penis in a wheelbarrow, early 20th century
Printed cartoon
3½" x 4½"
Unnumbered
Donated in 1946

Artists often exaggerate the size of the male organ for comic effect. The penis so large that a wheelbarrow is required to transport it has been illustrated countless times (one of the devils depicted by the French lithographer Eugène Lepoittevin is carrying his oversize phallus in this manner—plate 35). The erect penis is often shown as a versatile piece of equipment that can be used in ways that go far beyond its biological functions—it can become a plow, a fishing pole (plate 28), or even a ship's mast (plate 15).

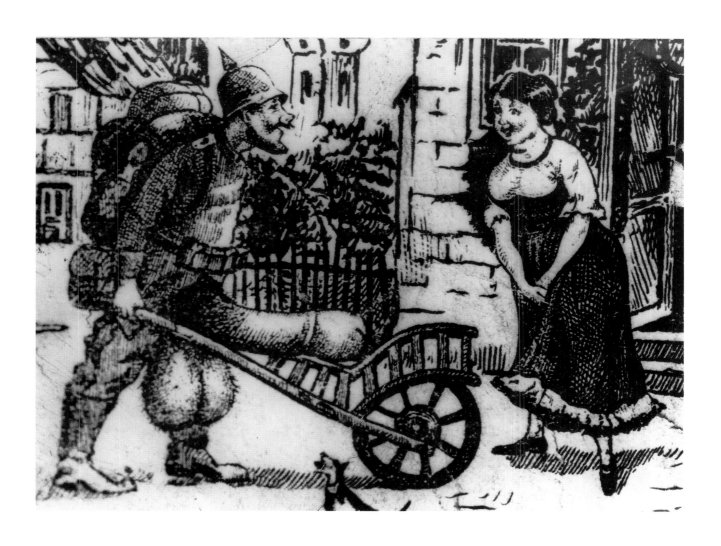

PLATE 37

UNKNOWN, UNITED STATES
Spring Plowing in Kansas, 20th century
Printed cartoon
$4^7/_8$" x 6"
Unnumbered
Donated in 1947

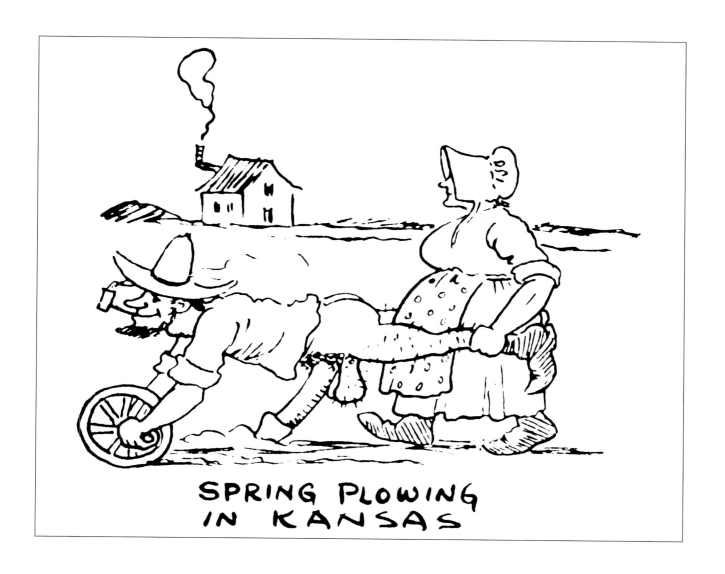

PLATE 38

VISET (1899–1939), BELGIUM
Men outside a bordello (illustration from *Lettres à la présidente*), c. 1927
Etching
6½" x 4⅛"
A397R V8297.3
Donated in 1980

In 1927 these fanciful compositions were used to illustrate a limited edition of Théophile Gautier's *Lettres à la présidente,* originally published in the mid–nineteenth century. The book contains sixty-five letters written by Gautier to Madame Sabatier, a famous Parisian courtesan whose salon was a popular gathering place for bohemian artists, writers, and musicians.

In one illustration Viset depicts a bordello scene—a copulating couple are being watched through the doorway by a line of men, who masturbate as they wait their turn; at the foot of the stairs several gentlemen appear to be comparing penises. The emphasis on the penis is even more evident in the illustration of phallic cannons, operated by nude female warriors. In an image that appears in a separate section titled *Gallanteries poétiques,* Viset turns to the female body, again depicting genitalia on an exaggerated scale—here a woman's vulva has become a mysterious cave that has attracted the interest of a group of Lilliputian explorers.

PLATE 39

VISET (1899–1939), BELGIUM
Phallic cannons (illustration from *Lettres à la présidente*), c. 1927
Etching
6" x 3⅛"
A397R V8297.1
Donated in 1980

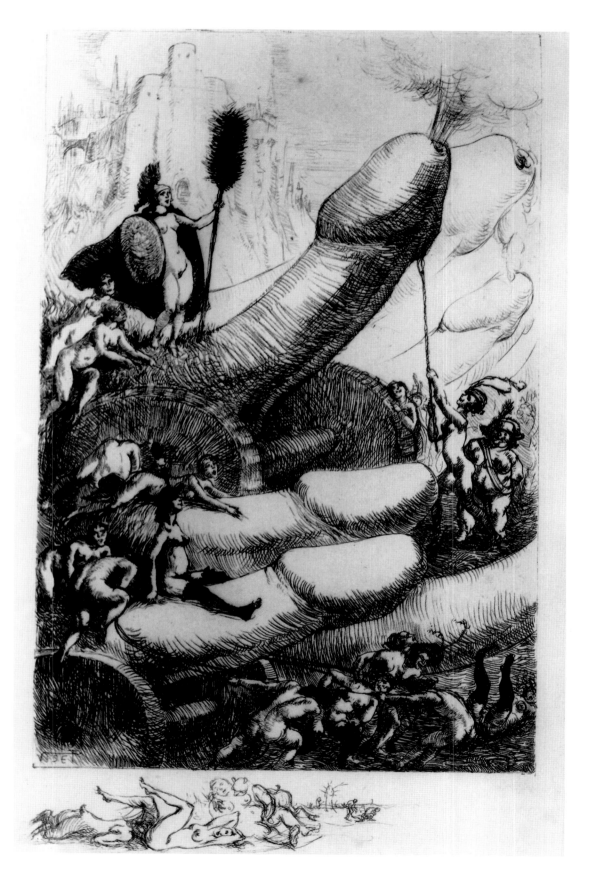

PLATE 40

VISET (1899–1939), BELGIUM
Lilliputian figures (illustration from *Lettres à la présidente*), c. 1927
Etching
4" x 6½"
A397R V8297.1
Donated in 1980

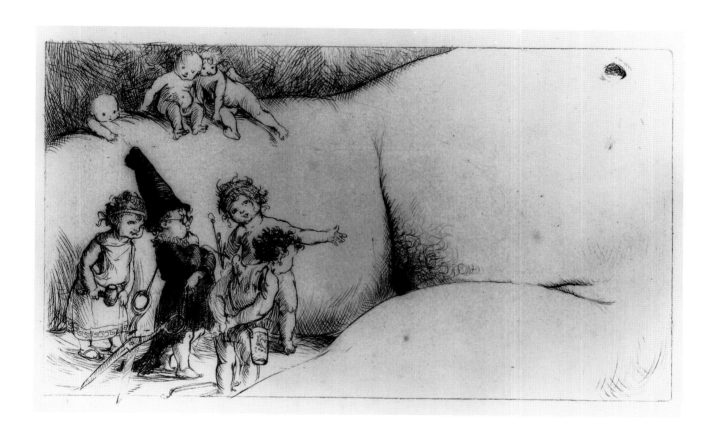

PLATE 41

HANS BELLMER (1902–1975), GERMANY
Female figure (illustration for *Madame Edwarda*), 1955
Etching
7$^{1}/_{8}$" x 3$^{1}/_{8}$"
A402R B4453.2
Donated in 1972
Copyright © 2001 Artists Rights Society (ARS), New York/ADAGP,
Paris

This etching is one of twelve illustrations Hans Bellmer created for
Madame Edwarda, a novel about a Parisian prostitute written by Georges
Bataille (under the pseudonym Pierre Angélique). Bellmer moved to
Paris in 1938, where he exhibited his work with the Surrealists. After
World War II he received a number of commissions to illustrate erotic
texts. In this illustration, the female figure's greatly enlarged vulva
provides a visual reference to the main character's profession, while it
also invites comparison with the much more frequent depictions of
exaggerated male genitalia.

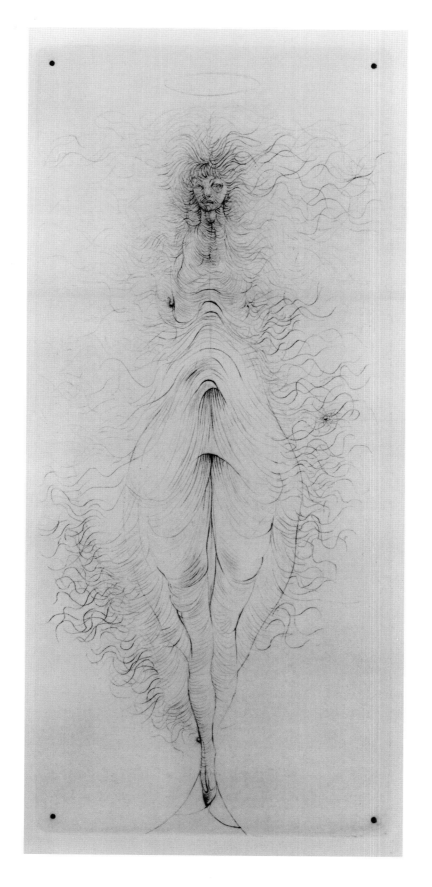

PLATE 42

REZSO MERÉNYI (1893–?), HUNGARY
Egér csók (Mouse kiss), 1922
Etching
5$^{1}/_{8}$" x 4$^{1}/_{8}$" (plate)
A470R M5596.4
Donated in 1950

A resident of Budapest, Rezso Merényi was a landscape painter as well as a graphic artist. In this etching, he applied to female anatomy the convention of depicting genitalia separate from the body. The vulva has become an element of the landscape, though its nearly normal scale is indicated by the two mice crouching at its base.

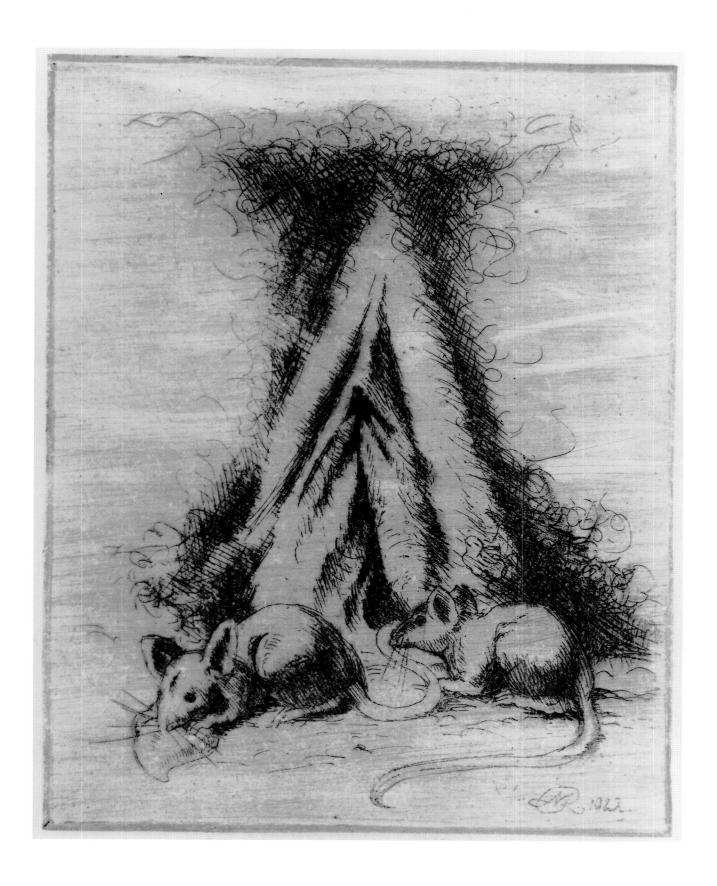

Exhibition Checklist

Most of the items in this exhibition were donated to The Kinsey Institute, and often little is known about their provenance. We apologize for any missing or inaccurate information in the checklist that may result from incomplete or incorrect documentation in our item records. If known, the following information is given for each piece: artist, country or area of origin, title or description (titles are in italics), date, medium or format, dimensions (height, width, and depth), Kinsey Institute collection number, and donation date.

Photographs

WILLIAM DELLENBACK (1917–2000),
UNITED STATES
Female figure made out of turnips, 1952
Gelatin silver print
9$^{1}/_{4}$" x 6$^{3}/_{8}$"
Unnumbered
Acquired in 1952

WILLIAM THOMAS, UNITED STATES
Augmented male physique image, mid–20th century
Gelatin silver print
9$^{1}/_{4}$" x 7"
Unnumbered
Donated in 1949

UNKNOWN, FRANCE
Couple in coitus with hat and umbrella, 1950–1955
Gelatin silver print
3$^{3}/_{4}$" x 4$^{3}/_{4}$"
KI-DC: 6613
Donated in 1964

UNKNOWN, FRANCE
Bride and groom, 1885–1890
Gelatin silver print
6$^{5}/_{8}$" x 4$^{3}/_{8}$"
KI-DC: 33303
Donated in 1958

UNKNOWN, UNITED STATES
Baby "reading" *Sexual Behavior in the Human Male,*
1948
Gelatin silver print
2$^{1}/_{4}$" x 4"
KI-DC: 44933
Donated in 1948

UNKNOWN, UNITED STATES
Man with erection leaning on column, mid–20th century
Gelatin silver print
7" x 4$^{7}/_{8}$"
KI-DC: 32101
Donated in 1958

UNKNOWN, UNITED STATES
Man and woman posed as Archer and Water Bearer,
20th century
Gelatin silver print
3⁵/₈" x 4⁷/₈"
KI-DC: 59710
Donation date unknown

UNKNOWN, UNITED STATES
Office worker in garters, c. 1955
Gelatin silver print
3³/₄" x 2⁵/₈"
KI-DC: 12430
Donated in 1964

UNKNOWN, UNITED STATES
Man and woman wearing jackets, 1936–1940
Gelatin silver print
4⁷/₈" x 3³/₄"
KI-DC: 44747
Donated in 1947

UNKNOWN, UNKNOWN
Woman seated on watermelon, 20th century
Color print
4¹/₂" x 3¹/₂"
KI-DC: 44908
Donated in 1974

UNKNOWN, UNKNOWN
Man fellating himself, 20th century
Gelatin silver print
3¹/₄" x 4³/₈"
KI-DC: 51042
Donated in 1961

UNKNOWN, UNKNOWN
Buttocks in water, mid–20th century
Gelatin silver print
4³/₈" x 6³/₈"
KI-DC: 51763
Donated in 1951

UNKNOWN, UNKNOWN
Elephants in coitus, early 20th century
Gelatin silver print
2¹/₄" x 4¹/₈"
KI-DC: 847
Donated in 1972

UNKNOWN, UNKNOWN
Penis as food, c. 1920
Gelatin silver print
5³/₄" x 4¹/₈"
KI-DC: 44723
Donated in 1950

UNKNOWN, UNKNOWN
Man and woman in coitus (acrobatic pose), c. 1945
Gelatin silver print
5³/₈" x 2⁷/₈"
KI-DC: 8344
Donated in 1964

UNKNOWN, UNKNOWN
Woman falling over fence (stereocard), 19th century
Gelatin silver print
3¹/₈" x 2⁵/₈" (image)
KI-DC: 67634
Donated in 1947

UNKNOWN, UNKNOWN
Seated woman looking at woman standing over her,
20th century
Gelatin silver print
3" x 2"
KI-DC: 39556
Donated in 1965

UNKNOWN, UNKNOWN
Four men urinating outdoors, 1916–1922
Gelatin silver print
3³/₈" x 5¹/₂"
KI-DC: 67249
Donated in 1961

UNKNOWN, UNKNOWN
Penis "face" with glasses and pipe, date unknown
Gelatin silver print
4½" x 3⅝"
KI-DC: 44918
Donated in 1947

UNKNOWN, UNKNOWN
Nude man and woman (Hitler parody), 1941–1943
Gelatin silver print
4¾" x 3⅝"
Unnumbered
Donated in 1953

UNKNOWN, UNKNOWN
Erect penis between two breasts, 20th century
Gelatin silver print
3½" x 4⅜"
KI-DC: 58950
Donated in 1972

UNKNOWN, UNKNOWN
Penis with hippopotamus statue, date unknown
Gelatin silver print
1¾" x 4½"
KI-DC: 44921
Donated in 1962

Paintings

ATTRIBUTED TO JEAN-BAPTISTE MALLET
(1759–1835), FRANCE
Man and woman in coitus, 1810
Oil, wood panel
5¼" x 7"
A397Q A019.1
Donated in 1947

UNKNOWN, FRANCE
Group sex scene in woodland setting, 19th century
Gouache
8" x 9⅜"
A397Q A024b
Donated in 1982

UNKNOWN, JAPAN
Men and women as sumo wrestlers, 20th century
Ink and colors on silk
9½" x 12"
A250R A183.1
Donated in 1953

Works on Paper

MARQUIS FRANZ VON BAYROS (1866–1924),
AUSTRIA
Woman charming phallus, late 19th or early 20th century
Engraving
6⅝" x 6¼" (image)
A364R B3617.2t
Donated in 1983

BEIER, UNITED STATES
Now—I Ban Able to Understood!, 1950
Ink
6⅛" x 4⅞"
Unnumbered
Donated in 1953

HANS BELLMER (1902–1975), GERMANY
Female figure (illustration for *Madame Edwarda*), 1955
Etching
7⅛" x 3⅛"
A402R B4453.2
Donated in 1972
Copyright © 2001 Artists Rights Society (ARS), New York/ADAGP, Paris

J. P. BESSOR, UNITED STATES
Chicopee Falls Volunteer Fire Department, 1966
Crayon
9½" x 12½"
A630R B5596.6
Donated in 1966

JUDY CHICAGO (1939–), UNITED STATES
Butterfly Vagina Erotica, 1975
Lithograph
42" x 32" (framed)
Collection of the artist
Copyright © Judy Chicago 1975

JEAN DUBUFFET (1901–1985), FRANCE
Le cortiège priapique, c. 1940
Color lithograph
13½" x 20¼" (image)
A397R D8213.1
Donated in 1948

MICHEL FINGESTEN (1884–1943), GERMANY
Navigare necesse est (bookplate for Gianni Mantero),
20th century
Engraving with watercolor
7⅛" x 9⅛"
A402R F4973.43
Donated in 1981

MICHEL FINGESTEN (1884–1943), GERMANY
Woman with monkey, 1920s
Engraving
2¾" x 6¾"
A402R F4973.2
Donated in 1948

MICHEL FINGESTEN (1884–1943), GERMANY
La Petite jardinière (bookplate for Gianni Mantero),
20th century
Engraving
6⅛" x 5" (plate)
A402R F4973.41
Donated in 1981

JARED FRENCH (1905–1988), UNITED STATES
Couple at the beach, c. 1945
Engraving
7¾" x 6" (image)
A630R F87441.1
Donated in 1950

GRAEWOLF, UNITED STATES
Men Fishing, mid–20th century
Graphite, colored pencil
7⅞" x 10½"
A630R S4357.3
Donated in 1962

WILLIAM HOGARTH (1697–1764), ENGLAND
Before, 1736
Engraving (first or second state)
20⅜" x 16⅝"
A371P H7157.1
Donated in 1950

WILLIAM HOGARTH (1697–1764), ENGLAND
After, 1736
Engraving (first or second state)
20⅜" x 16⅝"
A371P H7157.2
Donated in 1950

KATSUSHIKA HOKUSAI (1760–1849), JAPAN
Couple with cat and mice, from *Models of Loving
Couples* series, c. 1811
Woodblock print
9⅝" x 14⅝"
A250Q H7218.1A
Donated in 1985

HOLZER, UNKNOWN
Alkoven Don Giovanni (Mozart Suite), 1987
Etching
7¾" x 7⅝" (image)
Unnumbered
Donation date unknown

HOLZER, UNKNOWN
Tête-à-tête (Don Giovanni), Mozart Suite, 1987
Etching
7⁵/₈" x 7³/₄" (image)
Unnumbered
Donation date unknown

WILLIAM HURTZ, UNITED STATES
Je suis innocente!, 20th century
Colored pencil
8³/₄" x 6¹/₈"
A630R H9679.83
Donated in 1951

MAX KLINGER (1857–1920), GERMANY
Eve and the Serpent, from the *Eva und die Zukunft*
series published in 1919
Etching
9⁵/₈" x 4⁵/₈" (image)
A402R K656
Donated in 1950

ATTRIBUTED TO UTAGAWA KUNISADA (1786–
1864), JAPAN
Hell of Great Heat or *Cunt Hell of Great Searing Heat,*
early to mid–19th century
Woodblock print
13¹/₄" x 17³/₄"
A250Q A014.1
Donated in 1947

R. LEFTWICK, ENGLAND
Couple at nudist camp, c. 1950
Watercolor, ink
11" x 7¹/₂"
A371R L4957.9
Donated in 1960

CLIFFORD McCOLLAM, UNITED STATES
Man and woman in college setting, c. 1945
Ink, colored pencil
8" x 10¹/₂" (image)
A630R M1295. 2
Donated in 1956

REZSO MERÉNYI (1893–?), HUNGARY
Egér csók (Mouse kiss), 1922
Etching
5¹/₈" x 4¹/₈" (plate)
A470R M5596.4
Donated in 1950

REZSO MERÉNYI (1893–?), HUNGARY
Kíváncsiság (Curiosity), c. 1925
Etching
4" x 5¹/₈" (plate)
A470R M5596.3
Donated in 1950

MICHAEL MIKSCHE, UNITED STATES
Group of men involved in sexual activity, 1950s
Ink
8" x 24" (image)
A630R M6364.59
Donated in 1955

JOEL PETT, UNITED STATES
Patrick Buchanan and The Kinsey Institute, 1983
Ink
9" x 12"
Unnumbered
Donation date unknown

M. E. PHILIPP (1887–?), GERMANY
Das rotgeblumte Kanapee, 1912
Engraving
5¹/₂" x 7" (image)
A402R P5515.2
Donated in 1985

FÉLICIEN ROPS (1833–1898), BELGIUM
L'idole, from *Les sataniques,* 19th century
Etching
8⁷/₈" x 6¹/₈" (image)
A366Q R7857.5
Donated in 1949

THOMAS ROWLANDSON (1756–1827),
ENGLAND
The Sanctified Sinner, late 18th or early 19th century
Engraving (copy)
5⁷/₈" x 4" (image and text)
A371Q R8831.3
Donation date unknown

CYRIL SATORSKY (1927–), ENGLAND
Racing His Snails, illustration from *A Pride of Rabbis*,
1970
Linocut
13¹/₄" x 8¹/₄"
A371R S2536.1
Donated in 1972
Copyright © 1970 by Cyril Satorsky. All rights
reserved.

HENRI SOMM (1810–1889), FRANCE
La legion d'honneur, 1860s
Ink, graphite
9⁵/₈" x 7³/₈"
A397Q S6973.1
Donated in 1950

MARCEL VERTES (1895–1961), HUNGARY
Two men dancing, 20th century
Color lithograph
15" x 22¹/₄"
A470R V5673.1
Donation date unknown

VISET (1899–1939), BELGIUM
Lilliputian figures (illustration from *Lettres à la
présidente*), c. 1927
Etching
4" x 6¹/₂"
A397R V8297.1
Donated in 1980

VISET (1899–1939), BELGIUM
Phallic cannons (illustration from *Lettres à la
présidente*), c. 1927
Etching
6" x 3¹/₈"
A397R V8297.1
Donated in 1980

VISET (1899–1939), BELGIUM
Men outside a bordello (illustration from *Lettres à la
présidente*), c. 1927
Etching
6¹/₂" x 4¹/₈"
A397R V8297.3
Donated in 1980

UNKNOWN, EUROPE
Boy with statue (series of four), 1950s
Ink, watercolor
9" x 5¹/₂"
A350R A002.6–9
Donated in 1969

UNKNOWN, FRANCE
Man examining woman's buttocks with eyeglass, c. 1774
Engraving
5¹/₈" x 3³/₈"
Kinsey Library E 710 Alg
Donated in 1950

UNKNOWN, FRANCE
Group sex scene in outdoor setting, date unknown
Engraving
4" x 2¹³/₁₆"
A397R A072
Donated in 1947

UNKNOWN, FRANCE
Le fakir ou la force de volonté (The fakir or the strength
of will), c. 1942
Ink
7¹/₈" x 5³/₄" (image)
A397R A047b
Donated in 1983

UNKNOWN, FRANCE
Woman and phallus in 18th-century costume, 20th
century
Etching
7" x 5¹/₈" (plate)
A397R A058b
Donated in 1985

UNKNOWN, FRANCE
Woman examining man's genitals with eyeglasses,
20th century
Etching
7" x 5" (plate)
A397R A058f
Donated in 1985

UNKNOWN, FRANCE
Toutou, 1870
Watercolor
7⁵/₈" x 5¹/₂" (image)
A397Q A010.1
Donated in 1947

UNKNOWN, FRANCE
Crispation nerveuse, 19th century
Colored lithograph
12¹/₂" x 9⁷/₈"
A397Q A0001.8
Donated in 1964

UNKNOWN, GERMANY
Couple in coitus and phallic traveler (from album of
drawings), c. 1850
Graphite
9¹/₄" x 12³/₄" (album)
A402Q A007
Donated in 1977

UNKNOWN, JAPAN
Scene from *Yōbutsu-Kurabe* (The phallic contest), 19th
century
Woodblock print
4" x 6¹/₄"
A250Q A040a
Donated in 1954

UNKNOWN, UNITED STATES
Cocks (two pieces), 19th century
Wood engraving
2¹/₃" x 1³/₄" (image)
1⁷/₈" x 1³/₄" (image)
A630Q A007.1–2
Donated in 1964

UNKNOWN, UNITED STATES
"Well—What the Hell Are You Staring At?" 1940s
Ink, colored pencil
6⁷/₈" x 9"
A630R A764
Donated in 1981

UNKNOWN, UNKNOWN
Man and woman in coitus on couch, mid–20th
century
Graphite
8⁵/₈" x 11¹/₈"
Anon. Art Set #25H #7
Donation date unknown

Books

PARKE CUMMINGS, UNITED STATES
The Whimsey Report, or Sex Isn't Everything, 1948
Book
8¹/₄" x 5¹/₂"
Kinsey Library 770 C97u
Acquired in 1948

ROBERT GRAYSON, UNITED STATES
See Dick, Run, 1991
Artist book
2¹/₂" x 8¹/₂" x ⁵/₈"
Unnumbered
Donated in 1991

LAWRENCE LARIAR, UNITED STATES
Oh! Dr. Kinsey!, 1953
Book
9" x 6½"
Kinsey Library 770.2 L320
Acquired in 1953

EUGÈNE MODESTE EDMOND LEPOITTEVIN
(1806–1870), FRANCE
Charges et décharges diaboliques, c. 1832
Book of lithographs
10½" x 13¾"
Kinsey Library E710 L593c
Donated in 1958

CHARLES PRESTON, UNITED STATES
A Cartoon Guide to the Kinsey Report, 1954
Book
6½" x 4¼"
Kinsey Library K771 P93c
Acquired in 1954

BILL WENZEL, UNITED STATES
The Flimsey Report, 1953
Book
11" x 8"
Kinsey Library 772.1 W48P
Acquired in 1953

UNKNOWN, UNITED STATES
Eight-pagers, 20th century
Printed comic books
3" x 4–4½"
Kinsey Library
Various donation dates

UNKNOWN, UNITED STATES
Mae West (oversize eight-pager), 20th century
Printed comic book
4" x 5⅜"
Kinsey Library #653A
Donated in 1947

UNKNOWN, UNITED STATES
Around the World with Mae West (oversize eight-pager),
20th century
Printed comic book
6" x 3¾"
Kinsey Library #656
Donation date unknown

Three-Dimensional Objects and Ephemera

CISSIE, UNITED STATES
You Think You're Getting Old and Flimsy?, 20th century
Greeting card
5⅞" x 4½"
Unnumbered
Donated in 1959

MIKE DOWDALL AND PAT WELCH, UNITED
STATES
Human Sexuality . . . Humans; Fig. 8, 1984
Printed poster
28" x 20"
Unnumbered
Donation date unknown

GILLETTE A. ELVGREN (1914–1980), UNITED
STATES
Going Up, 1946
Calendar
9½" x 7⅜"
Unnumbered
Donation date unknown

REAMER KELLER AND PERCY BARKER,
UNITED STATES
Sexual Misbehavior in the Human Female, 1953
36 paper cocktail napkins in original box
6½" x 6½" x 1½"
A630R A398.1/ISR 400
Donated in 1953

CAROL STANLEY, UNITED STATES
The Whimsey Report, mid–20th century
Printed cotton handkerchief
13½" x 13½"
Unnumbered
Donation date unknown

E. I. THOMPSON AND VIC GREEN, UNITED
STATES
Newswheel G.I. Cartoons, nos. 1–3, 20th century
Printed cartoons in envelope
7½" x 9⅛" (folded)
Unnumbered
Donated in 1951

ZITO, UNITED STATES
Your Proposition Is Too Small, 20th century
Color postcard
3½" x 5½"
Unnumbered
Donation date unknown

UNKNOWN, AUSTRIA
Barrel containing nude man and woman, 20th century
Bronze
3" x 4" x 3"
A364R A008.1/ISR 1504
Donated in 1977

UNKNOWN, AUSTRIA
Can-can dancer, 20th century
Bronze
1½" x 4½" x 1⅜"
A364R A012/KI 2808
Donated in 1980

UNKNOWN, BELGIUM
Manneken-Pis (two pieces), 20th century
Postcard booklets
3½" x 5½"
3¾" x 5¾"
Unnumbered
Donation date unknown

UNKNOWN, CHINA
Figurine (basket, with male figure on top and couple
in coitus inside), 20th century
Ivory, pigment
1⅝" x 1⅝" x 1⅛"
A218R A042a-b/KI 2641a–b
Donated in 1984

UNKNOWN, CHINA
Wind-up Whackin' Willy, 1999
Plastic figurine
9" x 4½" x 1¾" (in original package)
2000.22.100
Donated in 2000

UNKNOWN, CHINA
Phallic figure, c. 1940
Wood
4½" x 1½" x 1¾"
A218R A041/KI 2624
Donated in 1983

UNKNOWN, CHINA
Toy mouse with enlarged male genitalia, 1990s
Fabric, plastic
12½" x 5" x 4"
99.18.1
Donated in 1999

UNKNOWN, CHINA
Toy rabbit with enlarged male genitalia, 1990s
Fabric, plastic
12" x 5" x 4"
99.18.2
Donated in 1999

UNKNOWN, EL SALVADOR
Priest kneeling (two pieces), 20th century
Ceramic, paint
2½" x 2½" x 3½"
A803R A001.1/ISR 1286
A803R A003.1/ISR 1376
Donated in 1973

UNKNOWN, EUROPE
Carved ball containing human and animal figures,
19th century
Ivory
$1^{1}/_{2}$" x 2" x 2"
A350Q A005.1/ISR 1538
Donated in 1977

UNKNOWN, EUROPE
Phallus as Kaiser Wilhelm, 1910s
Iron
$5^{3}/_{8}$" x $1^{5}/_{8}$" x $2^{1}/_{2}$"
A350R A064/KI 2714
Donated in 1981

UNKNOWN, EUROPE
Cigar box with two painted lids, 20th century
Tin, paint
$4^{1}/_{8}$" x $2^{3}/_{4}$" x 1"
A350R A026.1/ISR 1365
Donated in 1959

UNKNOWN, FRANCE
Snuff box, 20th century
Wood, lacquer
$^{3}/_{4}$" x $3^{5}/_{16}$"
A397R A014.1/ISR 1305/1305a
Donated in 1972

UNKNOWN, GERMANY
Soldier carrying his penis in a wheelbarrow, early 20th
century
Printed cartoon
$3^{1}/_{2}$" x $4^{1}/_{2}$"
Unnumbered
Donated in 1946

UNKNOWN, GERMANY
Interesting Reading . . . , c. 1913
Color postcard
$3^{1}/_{2}$" x $5^{1}/_{2}$"
Unnumbered
Donated in 1963

UNKNOWN, GERMANY
Zwei Seelen und ein Gedanke, early 20th century
Color postcard
$3^{5}/_{16}$" x $4^{13}/_{16}$"
Unnumbered
Donated in 1946

UNKNOWN, JAPAN
Hakata figurine (cat, with couple in coitus under-
neath), 20th century
Ceramic, paint
$2^{3}/_{4}$" x $6^{1}/_{2}$" x 3"
A250R A232/KI 2726
Donated in 1979

UNKNOWN, JAPAN
Hakata figurine (woman with book, man is underneath
robe), 20th century
Ceramic, paint
$5^{1}/_{2}$" x 7" x $5^{1}/_{2}$"
A250R A215/ISR 2630
Donated in 1983

UNKNOWN, JAPAN
Hakata figurine (sleeping boy with cat, couple in
coitus underneath), 20th century
Ceramic, paint
$3^{1}/_{8}$" x $5^{1}/_{2}$" x $5^{1}/_{2}$"
A250R A226/KI 2711
Donated in 1979

UNKNOWN, JAPAN
Woman inserting dildo in giant vagina, 20th century
Ceramic, paint
6" x 8" x 4"
A250R A034.1/ISR 518
Donated between 1951 and 1959

UNKNOWN, JAPAN
Male and female monkeys, 20th century
Clay
$7^{1}/_{4}$" x $3^{1}/_{2}$"
A250R A153.1/ISR 1311
Donated in 1972

UNKNOWN, JAPAN
Phallus as human figure, 20th century
Wood, paint
5³/₄" x 1⁷/₈" x 1⁷/₈"
A250R A278a–c
Donated in 1987

UNKNOWN, JAPAN
Great God—I Said Kit *Inspection!!,* 20th century
Silk handkerchief
11" x 11"
A250R A248/KI 2793
Donated in 1978

UNKNOWN, KABARDINO-BALKARIA (formerly
U.S.S.R.)
Animated figures in coitus, 20th century
Copper
3" x 2"
A290R A001/ISR 3216
Donated in 1986

UNKNOWN, MEXICO
Fuente del Niño, 1950s
Color postcard
5¹/₂" x 3³/₈"
Unnumbered
Donated in 1958

UNKNOWN, MEXICO
Phallus as nun, 20th century
Plaster, paint
7¹/₄" x 1¹/₂"
A585R A021.1/ISR 330
Donated in 1954

UNKNOWN, MEXICO
Setting hens (two pieces), 20th century
Ceramic, paint
2³/₄" x 3³/₄" x 2³/₈"
A585R A009.1/ISR 1258
A585R A009.4/ISR 1262
Donated in 1965

UNKNOWN, PHILIPPINES
Man in coffin ("A good man"), 20th century
Wood
1³/₈" x 2¹/₄" x 6¹/₄"
A288R A004/KI 2843
Donated in 1978

UNKNOWN, ROMAN EMPIRE
Figure holding elongated penis, 3rd century BCE/3rd
century CE (replica)
Clay or plaster
5¹/₂" x 3³/₄" x 4"
A472J A007.1/ISR 786
Donated in 1965

UNKNOWN, SWITZERLAND
Man and woman at guard post, early 20th century
Color postcard
2¹/₈" x 5¹/₂"
Unnumbered
Donated in 1946

UNKNOWN, TAIWAN
Animated figures, 20th century
Metal
3" x 1¹/₂"
Unnumbered
Donation date unknown

UNKNOWN, THAILAND
Man in a barrel (two pieces), 1990s
Wood
7" x 2¹/₂" x 2¹/₂"
97.6.1–2
Donated in 1997

UNKNOWN, UNITED STATES
Comic cards, mid–20th century
Printed cartoons in envelope
2³/₄" x 4"
Unnumbered
Donation date unknown

UNKNOWN, UNITED STATES
Comic cards, mid–20th century
Printed cartoons in envelope
2³/₄" x 4"
A630R A887a–m/KI 2905a–m
Donated in 1977

UNKNOWN, UNITED STATES
"That's a mighty handy little gadget . . . ," mid–20th
century
Printed cartoon
3¹/₂" x 2¹/₂"
Unnumbered
Donated in 1961

UNKNOWN, UNITED STATES
Foxy Granduncle's First Mistake, 20th century
Folded card (advertisement for cigars)
6" x 3" (closed)
Unnumbered
Donated in 1961

UNKNOWN, UNITED STATES
What You Can Do about Sex after 60, 1951
Printed cover, containing blank pages
5¹/₈" x 3¹/₄"
Unnumbered
Donated in 1955

UNKNOWN, UNITED STATES
Speaking of Sex . . . , 1950s
Greeting card
6" x 5"
Unnumbered
Donated in 1956

UNKNOWN, UNITED STATES
For a 'D'-Light-Ful Easter . . . , 1950s
Printed advertisement
7" x 9¹/₈"
Unnumbered
Donated in 1956

UNKNOWN, UNITED STATES
I Could Have Sweared I Saw a Torpedo, 20th century
Printed cartoon
3³/₄" x 3³/₄"
Unnumbered
Donated in 1947

UNKNOWN, UNITED STATES
P.T. Boats, 1943
Postcard
5³/₈" x 3³/₈"
Unnumbered
Donated in 1954

UNKNOWN, UNITED STATES
When the Subway Lights Go Out . . . , mid–20th century
Fold-out card
5⁵/₈" x 8" (folded)
Unnumbered
Donated in 1961

UNKNOWN, UNITED STATES
Merry Christmas, 1930s
Postcard
4⁷/₈" x 3¹/₈"
Unnumbered
Donated in 1946

UNKNOWN, UNITED STATES
It's Nice Here . . . , 1945
Color postcard
3¹/₂" x 5¹/₂"
Unnumbered
Donated in 2001

UNKNOWN, UNITED STATES
What Is Life without a Wife, 20th century
Animated card
5¹/₂" x 3¹/₂"
A630R A101.1/ISR 349
Donated in 1946

UNKNOWN, UNITED STATES
Spring Plowing in Kansas, 20th century
Printed cartoon
4⅞" x 6"
Unnumbered
Donated in 1947

UNKNOWN, UNITED STATES
I Don't Want Even a Little Piece, 20th century
Printed cartoon
2¼" x 3¾"
Unnumbered
Donated in 1948

UNKNOWN, UNITED STATES
The Office Party, c. 1960
Movie poster
42" x 28"
A630R A023
Donated in 1978

UNKNOWN, UNITED STATES
Novelty condom (tip shaped like an elephant), 1959
Latex
13" x 2" x 2"
A630R A466.1/ISR 631
Donated in 1959

UNKNOWN, UNITED STATES
Novelty condom (tip shaped like a human hand),
1940s
Latex
8¼" x 2½" x 2½"
A630R A441.1/ISR 203
Donation date unknown

UNKNOWN, UNITED STATES
Novelty condom (tip shaped like a bird's head),
c. 1950
Latex, ivory
6" x 1¾" x 1¾"
A630R A134.1/ISR 440A
Donated in 1954

UNKNOWN, UNITED STATES
Novelty condom (tip shaped like a man with a fiddle),
1959
Latex
13" x 2" x 2"
A630R A471.1/ISR 630
Donated in 1959

UNKNOWN, UNITED STATES
Novelty condom (tip shaped like a cowgirl), 1960
Latex
13" x 2½" x 2½"
A630R A438.1/ISR 675
Donation date unknown

UNKNOWN, UNITED STATES
Butcher with penis on display, mid–20th century
Ceramic ashtray
5½" x 5½" x ¾"
A630R A105.1/ISR 640
Donated in 1960

UNKNOWN, UNITED STATES
Phallus as priest, 1950s
Brass, paint
3¾" x 1½"
A630R A412.1/ISR 433
Donation date unknown

UNKNOWN, UNITED STATES
I Want a Good Girl—And I Want Her Bad, 1912
Color postcard
5½" x 3½"
Unnumbered
Donated in 1963

UNKNOWN, UNITED STATES
The Office Party, mid–20th century
Printed cartoon
4⁹⁄₁₆" x 5⅞"
Unnumbered
Donated in 1961

UNKNOWN, UNITED STATES
Annual Outing of the Temperance League of America,
c. 1900
Printed cartoon
5¹/₈" x 6³/₄"
Unnumbered
Donation date unknown

UNKNOWN, UNITED STATES
Why, Mr. Glotz, You're Such a Little Man!, 20th century
Printed cartoon
4" x 4¹/₂"
Unnumbered
Donated in 1947

UNKNOWN, UNITED STATES
Tillie, I Can Read You Like a Book, 20th century
Fold-out card
6¹/₈" x 3⁵/₈"
Unnumbered
Donated in 1947

UNKNOWN, UNITED STATES
Don't You Find Most Men Tiresome at Love Making?,
20th century
Fold-out card
6¹/₂" x 3³/₄"
Unnumbered
Donated in 1947

UNKNOWN, UNITED STATES
Casey's Tool Works, 20th century
Mirror
2" x 3"
A630R 697.1/ISR 1590
Donated in 1977

UNKNOWN, UNITED STATES
Oh Clarence Be Careful, 20th century
Mirror
2" x 3"
630R 697.2/ISR 1591
Donated in 1977

UNKNOWN, UNITED STATES
Woman holding mirror, 20th century
Mirror
2" x 3"
A630R 697.3/ISR 1592
Donated in 1977

UNKNOWN, UNITED STATES
Man reading the "Kinsley" report, c. 1953
Cardboard plaque
10" x 14" x ¹/₄"
A630R A246.1/ISR 371
Donated in 1955

UNKNOWN, UNITED STATES
Cigarette case with Hindu snake charmer on lid,
1940s
Metal
1³/₄" x 2⁷/₈" x ³/₄"
A630R A350.1/ISR 154
Donation date unknown

UNKNOWN, UNITED STATES
Phallus as bride, c. 1950
Rubber
6¹/₂" x 2" x 2"
A630R A133.1/ISR 308
Donated in 1951

UNKNOWN, UNITED STATES
Animated figures, 20th century
Wood, paint
8³/₄" x 2³/₄" x ³/₄"
A630R A282.1/ISR 331
Donated in 1952

UNKNOWN, UNITED STATES
Novelty shell containing male and female figures, 20th
century
Brass
1" x 2¹/₂" x 2"
A630R A212.1/ISR 912
Donated in 1965

UNKNOWN, UNITED STATES
Novelty shell containing male and female figures, 20th century
Bronze
1" x 2" x 2"
A630R A661.1/ISR 1509
Donated in 1977

UNKNOWN, UNITED STATES
Woman revealing her genitals, 20th century
Cast iron
3" x 2$^1/_2$" x $^1/_4$"
A630Q A011.1/ISR 917
Donated in 1965

UNKNOWN, UNITED STATES
Wimpus Joe (man with penis in wheelbarrow), 1920s
Bronze ashtray
4" x 4" x $^5/_8$"
A630R A807/KI 2815
Donated in 1982

UNKNOWN, UNITED STATES
Eat Drink and Make Merrie, 1960s
Movie poster
42" x 28"
A630R A023.6
Donated in 1978

UNKNOWN, UNITED STATES
Christmas cards, mid–20th century
Printed cards in album
7" x 10"
Unnumbered
Donation date unknown

UNKNOWN, UNITED STATES
Masturbating monkey, 1940s
Pipe cleaners, paper, string
1$^1/_8$" x 1$^7/_8$" x 2$^3/_4$"
A630R A333.1/ISR 20
Donation date unknown

UNKNOWN, UNITED STATES
Astrological signs associated with coital positions, 1970s
Poster
36$^5/_8$" x 23$^3/_4$"
A630R A012.1
Donation date unknown

UNKNOWN, UNITED STATES
With warmest wishes . . . , 1950s
Wool, cardboard
1$^1/_4$" x 6" x 3$^1/_2$" (box)
A630R A401.1/ISR 470
Donation date unknown

UNKNOWN, UNKNOWN
Hitler and Stalin animated figures, mid–20th century
Plastic, metal
2$^1/_4$" x 3$^1/_2$"
Unnumbered
Donation date unknown

UNKNOWN, UNKNOWN
What Were You Thinking About Then Jack . . . , early 20th century
Color postcard
5$^1/_2$" x 3$^1/_2$"
Unnumbered
Donated in 1959

UNKNOWN, UNKNOWN
Hold On There, I'm in For That too!, 20th century
Folded color postcard
3$^1/_2$" x 5$^5/_8$"
Unnumbered
Donated in 1946

UNKNOWN, UNKNOWN
Private, Keep Out, 20th century
Folded color postcard
5" x 3$^3/_8$"
Unnumbered
Donated in 1946

UNKNOWN, UNKNOWN
Peter Meter, 20th century
Wood
1" x 10"
Unnumbered
Donation date unknown

UNKNOWN, UNKNOWN
Peter Meter, 20th century
Glass, paper, liquid
5$\frac{1}{2}$" x 2"
Unnumbered
Donation date unknown

UNKNOWN, UNKNOWN
Winged male figure, 20th century
Wood, paint
6" x 9" x 8$\frac{3}{4}$"
Unnumbered
Donation date unknown

UNKNOWN, UNKNOWN
A Man's Best Friend, 20th century
Greeting card
7" x 5$\frac{1}{4}$"
Unnumbered
Donation date unknown

UNKNOWN, UNKNOWN
A Study in Fruit (two copies), date unknown
Folded color postcard
5$\frac{1}{2}$" x 3$\frac{1}{2}$"
Unnumbered
Donation date unknown

UNKNOWN, UNKNOWN
And THAT Miss Jones is how a torpedo works!, 20th century
Ceramic ashtray
$\frac{3}{4}$" x 4$\frac{1}{2}$" x 4$\frac{3}{4}$"
A001 A060/ISR 3210
Donation date unknown

UNKNOWN, UNKNOWN
Rusrotic (animated couple on wagon), 1991
Metal, wood, paint
9$\frac{3}{4}$" x 9" x 5"
Unnumbered
Donation date unknown

Selected Bibliography

Adelman, Bob. *Tijuana Bibles: Art and Wit in America's Forbidden Funnies, 1930s–1950s.* New York: Simon and Schuster Editions, 1997.

Ashbee, H. S. *Index Librorum Prohibitorum: Being Notes Bio-biblio-icono-graphical and Critical, on Curious and Uncommon Books.* New York: Documentary Books, 1962.

Bentley, Richard. *Erotic Art.* New York: Gallery Books, 1984.

Bowie, Theodore. "Erotic Aspects of Japanese Art." In *Studies in Erotic Art,* ed. Theodore Bowie and Cornelia V. Christenson. New York: Basic Books, 1970.

Falkon, Felix Lance. *A Historic Collection of Gay Art.* San Diego: Greenleaf Classics, 1972.

Kronhausen, Phyllis, and Eberhard Kronhausen. *Erotic Art: A Survey of Erotic Fact and Fancy in the Fine Arts.* New York: Grove Press, 1968.

Lucie-Smith, Edward. *Sexuality in Western Art.* London: Thames and Hudson, 1991.

Néret, Gilles. *Erotica Universalis.* Vol. 2, *From Rembrandt to Robert Crumb.* Cologne: Taschen, 2000.

Ouellette, William, and Barbara Jones. *Erotic Postcards.* New York: Excalibur Books, 1977.

Smith, Bradley. *Erotic Art of the Masters: The 18th, 19th, and 20th Centuries.* New York: The Erotic Art Book Society, 1979.

Taylor, Sue. *Hans Bellmer: The Anatomy of Anxiety.* Cambridge, Mass.: MIT Press, 2000.

Weiermair, Peter, ed. *Erotic Art from the 17th to the 20th Century: The Döpp-Collection.* Frankfurt am Main: Frankfurter Kunstverein, 1999; Zurich: Edition Stemmle, 1995.

List of Contributors

John Bancroft, M.D., trained in medicine at Cambridge University and in psychiatry at the Institute of Psychiatry, London. He is Director of The Kinsey Institute for Research in Sex, Gender, and Reproduction, and has more than thirty years of experience in various aspects of sex research. He is author of *Human Sexuality and Its Problems*.

Mikita Brottman, Ph.D., is the author of three books on the horror film: *Offensive Films; Meat Is Murder;* and *Hollywood Hex*. She has published articles in *New Literary History; Film Quarterly; Cineaction; Literature Film Quarterly; English Review; Studies in Popular Culture; Studies in American Humor; Biography; Humor;* and *The Chronicle of Higher Education*, and she also writes for a variety of alternative and underground publications in Britain and the United States. Formerly Visiting Assistant Professor of Comparative Literature at Indiana University, Bloomington, she is currently a member of the Liberal Arts Faculty at Maryland Institute College of Art in Baltimore.

Frank A. Hoffmann, Ph.D., is a folklorist and associate of The Kinsey Institute. He was the first folklorist to write a doctoral dissertation using materials in The Kinsey Institute Library (*An Analytical Survey of Anglo-American Traditional Erotica*). In retirement, he continues to organize and analyze folklore and popular culture ephemera in the Institute's library and archives.

Catherine Johnson has a master's degree in art history from the University of Oregon. She has curated exhibitions at The Fine Arts Museums of San Francisco and Indiana University's Lilly Library. She is Curator of Art, Artifacts, and Photography at The Kinsey Institute for Research in Sex, Gender, and Reproduction.

Betsy Stirratt is an artist and has been Director of the School of Fine Arts Gallery at Indiana University since 1987. She has curated numerous exhibitions, including *The Art of Desire: Erotic Treasures from the Kinsey Institute; Persona(l) Selections from the Robert J. Shiffler Collection;* and the upcoming *Divine*. Her artwork has been shown nationally, and she is the recipient of several grants and awards, including a Visual Artist Fellowship from the National Endowment for the Arts.

Carol Tavris, Ph.D., is a social psychologist and a Fellow of the American Psychological Association. She has taught in the psychology department at UCLA and at the Human Relations Center of the New School for Social Research in New York. Tavris is the author of *The Mismeasure of Woman: Why Women are not the Better Sex, the Inferior Sex, or the Opposite Sex* and *Anger: The Misunderstood Emotion*.

Leonore Tiefer, Ph.D., is a clinical psychologist and sexologist in New York City. She is Clinical Associate Professor of Psychiatry at New York University School of Medicine and Albert Einstein College of Medicine. Her most recent book is *Sex Is Not a Natural Act, and Other Essays* (1995), which is not a humor book, although it is not entirely without wit.

PHOTOGRAPHERS Chandra Ramey

Steve Weir

Jeffrey A. Wolin

IU Photographic Services